TOM HUNTER

Living in Hell and Other Stories

TOM HUNTER

LIVING IN HELL AND OTHER STORIES

Tracy Chevalier and Colin Wiggins

National Gallery Company, London

Distributed by Yale University Press

Published to accompany the exhibition *Tom Hunter: Living in Hell and Other Stories* at the National Gallery, London from 7 December 2005 to 12 March 2006.

First published in Great Britain in 2005 by
National Gallery Company Limited
St Vincent House
30 Orange Street
London WC2H 7HH
www.nationalgallery.co.uk

ISBN 1 85709 331 3
525480

British Library Cataloguing-in-Publication Data
A catalogue record is available from the British Library
Library of Congress Catalog Card Number 2005929891

Project Editor: Claire Young
Designer: Ben Weaver
Picture Researcher: Kim Klehmet
Production: Jane Hyne and Penny Le Tissier

Printed and bound in The Netherlands by Drukkerij Rosbeek

All measurements give height before width

Front cover:
Living in Hell, 2004
Lambda print
121.9 x 152.4 cm

CONTENTS

DIRECTOR'S FOREWORD

Charles Saumarez Smith
Director
The National Gallery, London

THERE MAY be people who find Tom Hunter's photographs uncomfortable, particularly when they see them in the context of the National Gallery, the home of the nation's greatest collection of Old Master paintings. They are extremely raw, concerned as they are with the reconstruction of events which take place every day in London.

But it is easy to forget that many Old Master paintings themselves use potent subject matter and exploit human emotions. Many are about murder and violence in the kingdom of the gods, as we see in the paintings of Piero di Cosimo, where the Lapiths and Centaurs fight to the death. The paintings of Hieronymus Bosch were not intended to be comfortable viewing, but in fact were painted precisely in order to shock viewers into the realisation of the consequences of sin. And Hogarth's modern morality tales, such as *Marriage A-la-Mode*, were painted with exactly the same subject matter as the photographs of Tom Hunter with the intention of reminding the comfortable bourgeois citizens in the West End of the uncomfortable realities of life in other parts of London, the undercurrents of violence in the eighteenth-century city.

Just as it is important to think about Tom Hunter's photographs in terms of traditional subject matter, so is it important to remember that these are not the scenes of violence themselves: they are *tableaux vivants* in the grand, theatrical manner of a painting by David, staged for dramatic effect and exploring the boundary between reality and fiction. They do not show someone being attacked or dying, but rather, a reconstruction. In this way, they prompt ideas about the ways in which

narrative worked in the past and how artists thought about and depicted events that happened long ago, including, not least, the violent events of Christ's Passion and Crucifixion. These photographs are not works of reportage, but of convenient fiction.

Tom Hunter's photographs are relevant and important to the National Gallery as they demonstrate the ways in which modern imagery is so deeply – sometimes consciously and sometimes more subliminally – influenced by the compositional luggage of the past with its repertoire of idioms and effects. Throughout his career as an artist, Tom Hunter has made a special use of Old Master paintings, including the works of Vermeer and, more recently, of Cranach, Rubens and Sebastiano del Piombo, in order to give presence and authority and resonance to his photographs. They work on two levels, as images with an immediate, powerful effect and, equally, as images which draw on the well of human emotion as expressed in the greatest paintings.

So, although at first sight the exhibition may appear surprising, perhaps even shocking, I hope that, on reflection, visitors will realise the power and immediacy of these works and their obvious debt to the art of the Old Masters.

MAKING AN ART OUT OF TELLING STORIES

Tracy Chevalier

EVERY WEEK two local newspapers arrive at our house. One we pay for, and it is full of stories of civic concern – plans for the nearby heath; analyses of the pros and cons of new bus routes; campaigns to restore historic buildings, or keep swimming ponds open, or force flyposting firms to stop putting up posters. There are stories about dogs helping their owners in distress, profiles of people who are running marathons to raise money for charity, coverage of local stage and television celebrities opening school fairs. The leader and letters pages bristle with indignation over local political issues as well as complaints about schools, parking, traffic, planning and development.

The other newspaper is shoved free through our door. I read it to find out who in the area has been vandalised, burgled, mugged, raped, murdered, arrested, convicted, imprisoned. If there is a story about an animal, it's likely to be about an abandoned rabbit found in a dustbin by a block of flats. If it's about a new bus route, the bus will have had an accident that has put two passengers in intensive care. The emphasis of the free paper is always on the grittier, harsher, more violent side of life.

There is, of course, some overlap between the two papers. Both always feature photographs of children engaged in activities at school – snapshots of innocence amidst the relentless grimness. Other stories also share headlines, but the attitude of each paper towards its subject is very different. If both papers report on the same violent story, for instance, the paid-for paper will do so through gritted teeth, at arm's

length, as if not quite willing to admit that this sort of thing could have happened here. The free paper, however, provides graphic details I would not find in the paid-for paper: the murder weapon had a six-inch blade, or the mugger broke the pensioner's collarbone, or the drug dealer had hospitalised his girlfriend twice in the last year. Recently both ran a photograph of a horrific murder scene, but either the free paper enhanced the blood or the paid-for paper airbrushed most of it away.

Tom Hunter has been drawn to dramatic headlines in his own local paper: 'Hallowe'en Horror: Trick or Treat Thugs Break Mum's Bones'; 'Naked Death Plunge'; 'Boy Finds Man's Body in River'; 'Rat in Bed'; 'Road Rage Thug Jailed for Attack on Priest'; 'Living in Hell'; 'Lover Set on Fire in Bed'. I am attracted by such headlines as well – if a paper with one of those on the front page were dropped on my doormat I would sit down at the kitchen table with a cup of coffee and read it.

Part of their power is being local. Played out on a national or global stage, such stories are distant; we respond to them intellectually rather than emotionally. When, however, the focus has been aimed at the familiar – on the streets we walk down, in the buildings we visit, amongst people we know – we feel much more personally involved.

Hunter has always displayed empathy for the local. He has championed the marginalised of Hackney – the squatters (he has been one himself), the travellers who live in caravans – as well as the neglected, unloved yet often beautiful spaces tucked between the urban landscape and the countryside, places only locals would know about. He could not portray such people and such places without actively engaging with the world immediately surrounding him. It makes perfect sense that he would read the local papers and take his inspiration from them.

He is probably best known for his series of photographs of Hackney dwellers in poses imitating paintings by the seventeenth-century Dutch painter Johannes Vermeer. *Woman reading a Possession Order* won the John Kobal Photographic Portrait Award in 1998 and brought his work to a wider public. I'm not surprised that Hunter was attracted to the work of Vermeer, who also explored the beauty and solitude of local life. Vermeer hardly left his hometown of Delft, and painted many of his 36 paintings in one corner of the same room. With his deft, delicate handling of light and colour, he was able to lay bare a whole world in that corner.

Hunter uses light and colour similarly, and with complete confidence. The sheer beauty of his technical work provides a solid base upon which we can build our contemplation of the stories he illustrates and extends. The contrast between subject matter and the beauty of its portrayal is perhaps the first sensation to strike us as we look at the photographs in the exhibition *Living in Hell and Other Stories*, where he has recreated scenes from local stories that have appealed to him. A boy looks at a body floating face-down in a river, its jacket a deep blue amidst the brighter blue sky reflected in the water. A woman sleeps naked in the yellow and orange glow of a side lamp and fairy lights, oblivious to the two rats in her bed. Boys gather around a prone woman they have attacked, bathed in lights that bring out the blood red of their jackets and jumpers. A man stands over a priest he has hit, a street light shining down beatifically on the two figures and creating striking patterns on the wall and road around them. An old woman sits in a room lined with pleasing wallpaper that turns out to be dotted with hundreds of cockroaches. A swan at the base of a footbridge attacks a woman wearing white shoes in clear, tranquil winter light. These are images whose beauty we initially rejoice in, until we are reminded of the hideousness of the situation: that is a dead body floating in the water; those rats may bite the woman; the priest is getting the shit kicked out of him; the old woman is not fighting the cockroaches but sitting amongst them. Then the beauty begins to feel treacherous, our interest voyeuristic.

★ ★ ★

Reporting on the grim drama of daily life is nothing new. When I was doing research for a novel set in London at the beginning of the twentieth century, I read through many issues of just the same sort of local newspaper, trawling it for snippets of wife-beating, drownings in ponds, and dead babies left under bushes. It provided a snapshot of the raw, unsanitised lives of people back then – sensationalised, admittedly, though only for a moment, or rather, for a week, when the next issue appeared and some new drama took over the front page.

Those lurid headlines – with their emotive phrases, large type and emphatic syntax stripped of unnecessary words – promise so much.

They are almost impossible to resist. If I see the free paper sitting on my doormat, half a headline reading, 'Murder Suspect Ate —', then I have to pick up the paper and find out that the suspect ate at the local Indian restaurant the night of the killing. I care about the story for at least as long as I'm reading it, and perhaps for the whole week – until it is replaced by a new sensation the following week.

Why do I read these stories? Do I need to be so well-informed about the brutality of twenty-first-century London life? Is it really helping me to know how close to my house I can buy drugs or be mugged? Am I being warned or am I revelling in others' misery for entertainment? It is a question I ask myself every time I read the paper, or every time I drive by a car accident and strain to see what has happened, even though the sight of blood or someone hurt or dead would make me feel sick.

Do we read these stories with a sense of 'There but for the grace of God go I'? Look, they happened to your neighbours – they can happen to you. Are they warnings about the random unfairness of life? It doesn't matter how clean and well lit your room is, you still might get rats in your bed. See what happens when you open the door to trick-or-treaters? Hooligans break your bones! And that boy wandering along the river – he only goes and finds a body there!

Or do we read them with a sense of *Schadenfreude*, and a bit of judgement too? What was that woman doing walking over the bridge at twilight – doesn't she know that it's dangerous for women to go out alone at that time of the day? The old woman with the cockroaches shouldn't just leave out pizza like that. What does she expect? And the trick-or-treat woman should never open the door to masked teenagers, Hallowe'en or not.

Perhaps we read the stories simply out of surprise that such things can happen in what seems on the day-to-day surface of it a calm, stable, even monotonous world. Everyday life is full of small, familiar moments strung together that repeat themselves over and over. We eat, we breathe, we walk, we sit, we talk, we sleep. How peculiar when something outside of that mantra erupts; it shakes the placid surface of daily life. That, whether we admit it or not, is thrilling.

I think we read about others' woes for all of those reasons – with sheer surprise and excitement that it can happen at all; with pity for

others, yes; but also with gratitude that it's not us, concern that it could be us, moral justification why it shouldn't be us. We read these sensational stories to make sense of our own lives, our circumstances and choices.

<center>★ ★ ★</center>

By their split-second nature, photographs cannot tell the whole story. Often we see the beginning of a story – the meeting, the kiss, the gun – but we don't know how it ends; or we see the end result – the wedding, the baby, the coffin, the prison – but we don't know how we got there. Tom Hunter has given us the middle slice of the story. We don't know how we arrived, or where we're going. How did the rats get in the bed, or the cockroaches on the wall, or the body in the river, and what will happen now that they're there? Hunter gives us no answers, but he does provide details that we can use to fill in the gaps ourselves.

I like looking at works of art and making up the stories they might depict. Perhaps it's the writer in me that makes me want to create narratives out of images, to translate the visual into the verbal, just as Hunter has done the opposite by making newspaper words into photographs. *Rat in Bed* feels particularly ripe for storymaking. I'm attracted to it in part because I hate rats, but also because it is perhaps at first less menacing than some of the other photographs in the exhibition. No one is dead or hurt – at least not yet. The setting is calm, clean, intimate. Best of all, the woman is asleep, blissfully unaware of her situation. She would be surprised to know she is in the middle of a story worthy of the local tabloid, whereas the other protagonists – the trick-or-treat mother, the woman attacked by the swan, the priest being shit-kicked, the old woman with her cockroaches – are all too aware that they are caught up in a drama.

When I look at *Rat in Bed*, I am immediately drawn in, not just to the moment – the rats sniffing around the woman in bed – but to speculation about the past and the future, the beginning and end of the story. Lots of questions pop into my head, first about what will happen next: will the rats run over her? Will they bite her? Will she wake up? Will she scream? Will they run off? Will she ring her mother/boyfriend/

landlord/rat catcher? Will someone get rid of the rats? I can more or less guess yes to all of these questions; the ending to this story is relatively predictable.

What went on before is much more mysterious. How long have the rats been there? And why is she asleep with the lights on? Does she always sleep like that? If so, why? Is she afraid of something? Wait a minute: isn't that a cat sleeping on the rug? Why isn't it awake and hunting the rats? Does the woman knows she has rats?

Nice lights on the bed, by the way. I like fairy lights as much as I hate rats, and I love the miniature oriental lantern look, an echo of the woman's Asian features. In fact, I find myself scrutinising everything in the room to find out more about her: the feathers in the wine bottle in the corner, the ostrich egg next to them, and especially the row of shoes. There is something so poignant about shoes lined up like that: shoes as ornament as much as footwear. I notice all the shoes have high heels, including slippers trimmed with fluffy pink feathers. They are the most useless slippers – you can't easily walk in them and they don't keep your feet warm – but they are sexy. Here is a woman who likes to look sexy even when eating cornflakes. In fact, it is those slippers, the feathers in the corner, and the woman's sleeping naked that makes me suspect she is a stripper, someone in control of her look and style and sexuality. There is something tastefully tawdry about the room, apart from the rats.

With all of this information, I find myself making up a story about her, and even giving her a name. (Tom Hunter's photographs are so specific that they often make me want to give names to the participants.) She is Lucy Yang, she is originally from Singapore, and she is a stripper. These last couple of weeks she's heard gnawing and rustling when she's been drifting off to sleep late at night, and she suspects she has rats. She's borrowed a friend's cat, and she's taken to sleeping with the lights on, to scare them off further. This night, however, two rats come out while she's asleep and run over her in bed. She screams, and they run off, pursued by an apologetic cat that catches nothing but spends the next hour posturing around the flat. Lucy can't possibly sleep now, so she sits up for the rest of the night reading magazines and talking on the phone to her mother back in Singapore, who thinks Lucy is studying nursing in

London. 'Come back,' her mother says. 'No rats in Singapore.' But there are rats in Singapore, Lucy knows. There are rats everywhere; didn't she just read in the paper that there's a rat just four feet away from wherever you are? In the morning she phones her boss, who knows all about pest control, and he sends over a rat catcher, who compliments Lucy on her fairy lights and a yellow kimono she wears, puts down poison and covers a hole in the bottom of the kitchen cupboard with tin.

See? It is easy to unpack and extend these images backwards and forwards. In *Rat in Bed* I find it easier to focus on the end of the story. With *Road Rage Thug Jailed for Attack on Priest*, the back story takes precedence. In this night-time scene, a priest lies in the road outside his church as a stocky man stands over him, having left his Range Rover with its lights on. The men are also lit by a street lamp that creates a pool of light around them. Religious statues on the church remain silent witnesses. Both priest and thug are utterly convincing in their body language. The thug strikes a menacing pose with his feet placed wide apart and his arms crossed over his chest, the line of his shoulder and arm tense and animalistic. The priest's hand is thrown to one side, his foot is awkwardly twisted, and his mouth and jaw are rigidly set in terror and indignation. All are such genuine physical embodiments of fear that they are infectious: when I look at this photograph for any length of time I feel fearful myself.

Again Tom Hunter plays with the visual beauty of the scene to – literally – make the violence stand out. The stunning ellipse of light creates unusual patterns on both the brick wall – where the mortar is picked out like the weave in a length of cloth – and the asphalt, a surge of yellow pebbles. These resolutely urban patterns lock the two men into their landscape, making their encounter feel inevitable and almost preordained.

According to the sub-headline, this confrontation is a clash over parking, the thug with his big, brutal Range Rover battling with the priest in his small car for a space. As with *Rat in Bed* and so many of his photographs, this raises questions I ache to answer: what has the priest done to warrant such an attack? Why is the thug so angry? Has the priest been hit yet? How badly will he be hurt? What will finally stop the thug? How does he feel attacking a priest – does this make the priest

more or less protected? I am fascinated by the religious context of this scenario, and feel somehow that it is the key to this story. Hunter has given me only one part of the story, though, and if I want to know more I will have to make it up.

Here is how I see it, then. Keith is a plumber and has had a bad day – non-payments, customers and contractors complaining, his ex-wife ringing at a bad time and making problems about his access to their kids. All he wants now is to play a little five-a-side football, with a drink in the pub after to help him forget the day. The traffic's bad and he's already running late when a poxy little Fiat Punto cuts in front of him and pulls over by a church. Keith pulls up behind it, with a sudden urge to let whoever's in the car know what a crap driver he is. He hasn't been able to tell anyone else what he thinks of them today, so he's going to do it now. He's only momentarily surprised when he pulls the Fiat Punto's door open to find that the driver is a priest. In fact, it makes him angrier. His mother is Catholic and spent much of Keith's childhood at Mass or do-gooding for the priest, and was never around for her son. Keith hates priests.

For his part, Father Dominic is indeed a terrible driver – so bad that he doesn't even know he has cut someone off. So he is completely taken by surprise when Keith hauls him out of his car and lays into him. He thinks this must be a religious fanatic, or some nutter put on the street because of a government policy to close local care facilities. Father Dominic does not have charitable Christian thoughts during this shit-kicking, which is understandable given the circumstances; nor does he pray, as you might expect. Instead he concentrates on protecting his vital organs and on searching for distinguishing marks on his attacker. He finds one – a tattoo of a Celtic cross on the back of Keith's neck. To Father Dominic it is the ultimate insult to the Church to see the cross decorating the neck of such a man. 'Bastard,' he thinks.

Apart from sporting the cross, Keith also makes the mistake of not beating Father Dominic unconscious. When he has at last got the rage at the day and at his mother out of his system, Keith drives off, and Father Dominic is just *compos mentis* enough to raise his head and memorise the car registration number. These two clues provide the outcome we already know from the headline – Keith will go to prison.

Hunter has made it easy to come up with such stories. Most of his photographs have enough incidental detail to stoke anyone's imagination and provide possible beginnings and endings. The photographs are all the more powerful because they remain unresolved. Their lives are extended by speculation, by the constant questions that stream through us as we look at them.

★ ★ ★

Tom Hunter has placed the stories – and indeed, storytelling itself – in a wider context by referencing paintings from the past. Many of the gestures and positioning of people in these photographs are taken from other, older paintings. The *Rat in Bed* woman, for example, is lying like the Gauguin woman in his painting *Spirit of the Dead Watching*. The old woman in *Living in Hell* resembles a woman in the Le Nain brothers' *Four Figures at a Table*. The priest in *Road Rage Thug Jailed for Attack on Priest* is lying in the same position as Christ in Guercino's *The Dead Christ mourned by Two Angels*. These old masterworks tell their own local stories. In Gauguin's painting the woman is terrified of the spirit of death who sits next to her bed. Or is she? Maybe it's just an old woman sitting by the girl's bed, keeping the rats away so that she can sleep. The Le Nain is a scene of peasants eating. Why does the mother look so grim, the girl so sad? Do they have enough to eat? As for Jesus Christ – well, that story has become rather more international, but it's worth remembering that at the time when it was all meant to have happened, the stories told about Jesus were simply versions of 'local boy made good before thugs done him in' that you might easily find in the *Hackney Gazette* or the *Jerusalem Journal*. There are even different angles of Jesus' story in the Gospels: Mark's is the most straight-forwardly biographical, while John's is spiritual, Matthew is writing for the middle classes (like the paid-for paper I get), and Luke emphasises the poor (the slant of the free paper).

When Jesus' story-makers began relating their tales, they doubtless had no idea that what they said would be collected and retain such an influence over so many people 2000 years later. Instead they probably had readers of the *Jerusalem Journal* in mind. Local journalists tend to think locally. I expect the reporters who wrote 'Rat in Bed' and 'Road

Rage Thug Jailed for Attack on Priest' never expected Tom Hunter to recreate the stories in photographs. Certainly the real 'Lucy,' 'Keith,' 'Father Dominic' and others from these stories must be surprised, bemused, maybe even outraged at being represented in this way. I hope they will not be too upset, though. Hunter has handled their stories skilfully, confidently, and with great aesthetic precision. Moreover, he has lured us into engaging with the stories, making them our own with imagined beginnings and endings. And he has placed these stories in a wider historical context, reminding us that tales have been told for as long as there have been people around to tell them. These slices of daily life, in all their pathos and savagery, may resonate far beyond the experience of their participants. Indeed, they already have: by choosing them for these photographs, Tom Hunter has ensured their immortality.

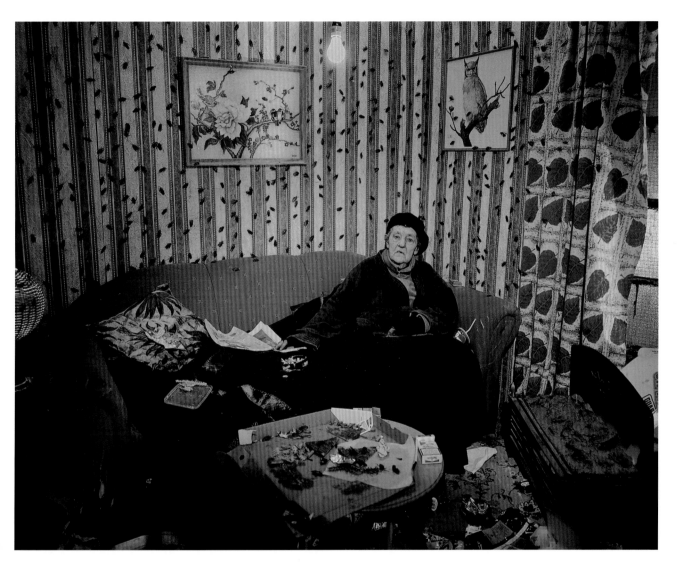

Living in Hell

Rat in Bed

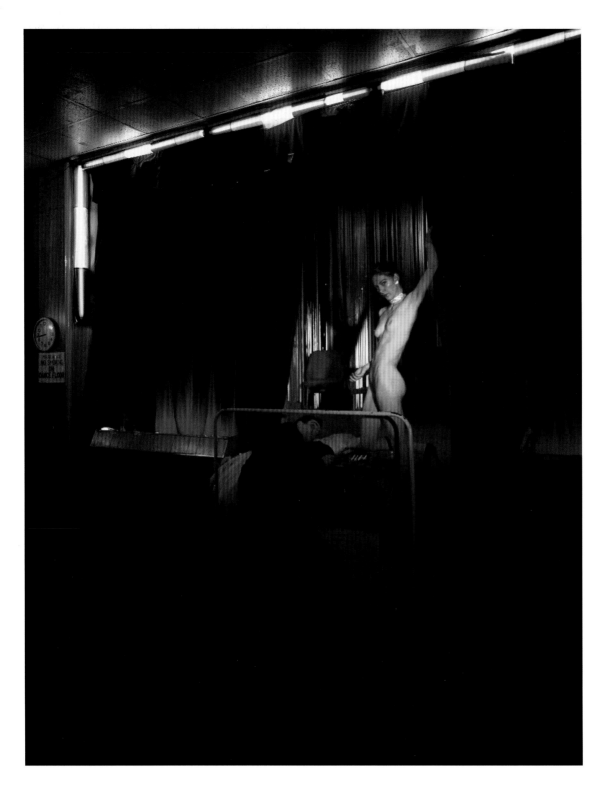

Girls' Sex Acts in Club: Court. Cop: 'It can only be described as having Sex through Clothes'

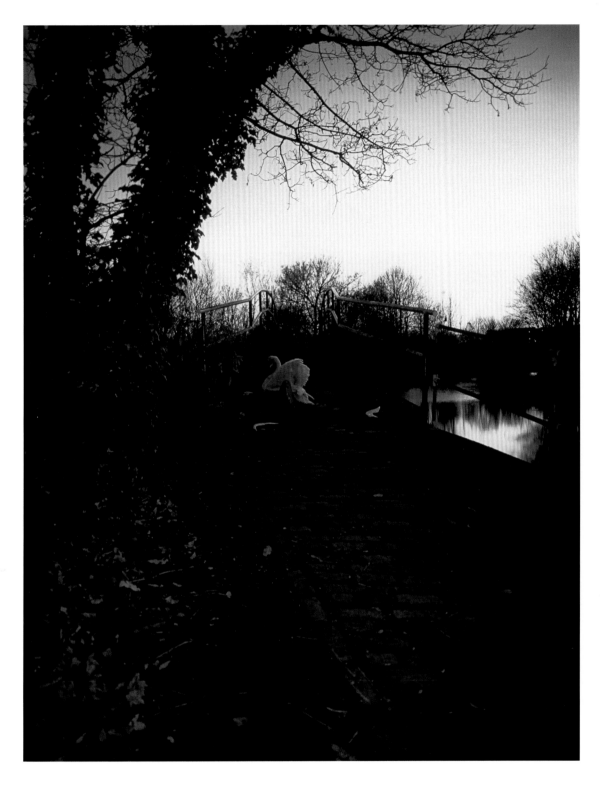

Up Before the Beak: Angry Swan guards Bridge after Crash

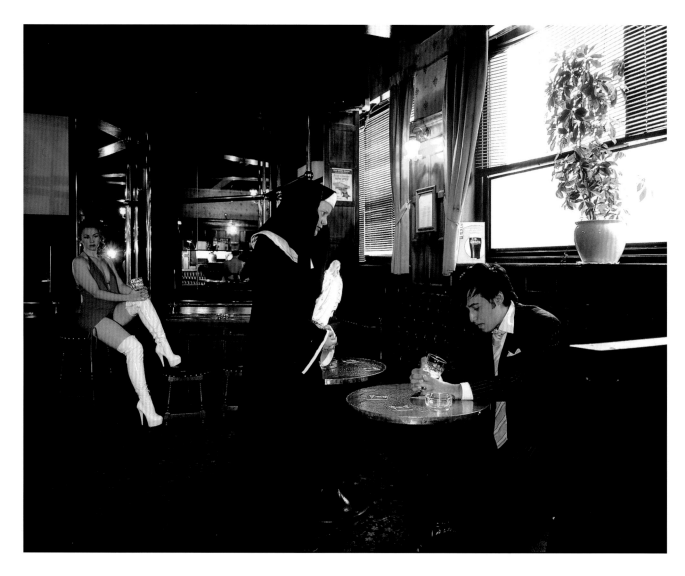

Nun tears Strip off Club Client

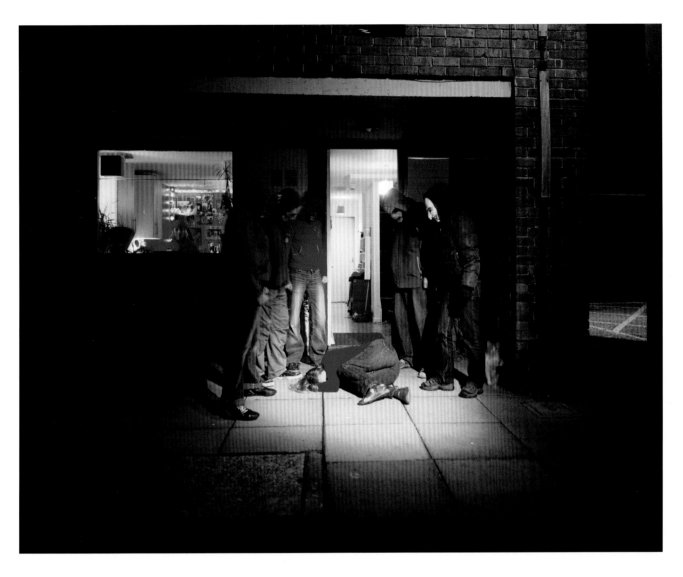

Hallowe'en Horror: Trick or Treat Thugs break Mum's Bones

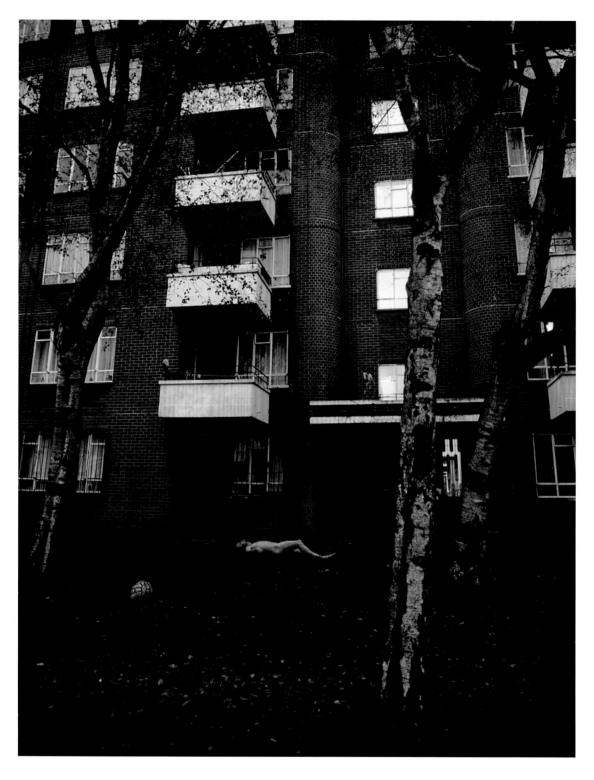

Naked Death Plunge

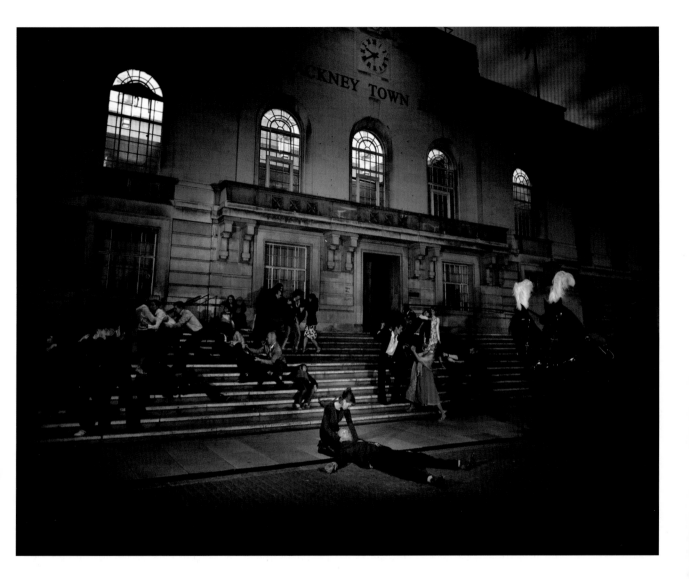

For Batter or Worse

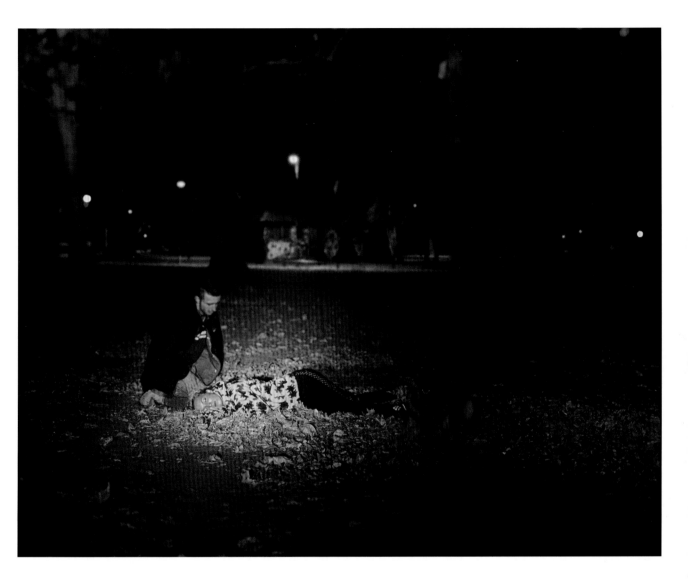

Murder: Two Men Wanted

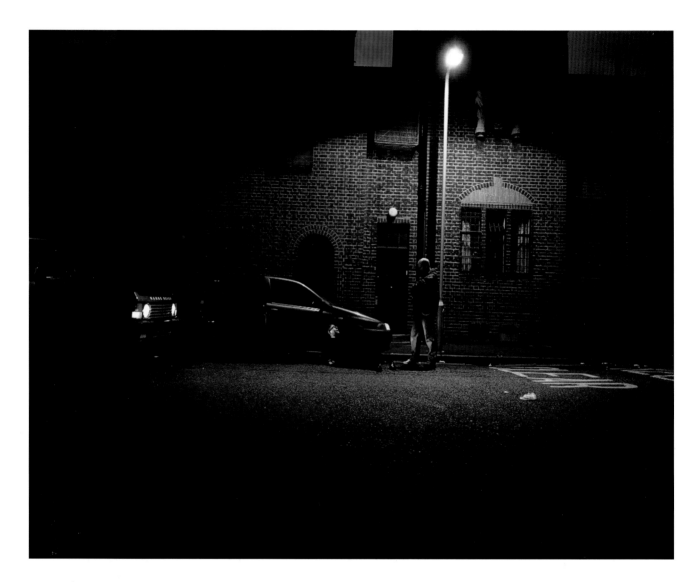

Road Rage Thug jailed for Attack on Priest

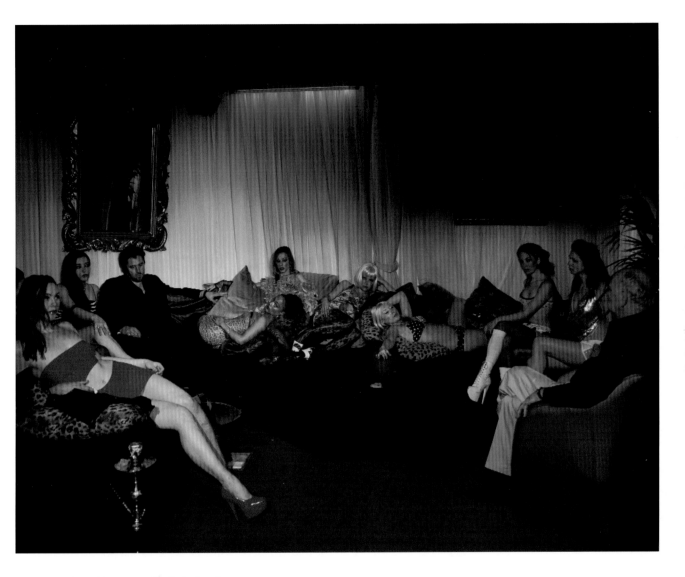

Father and Son run £2m Vice Racket from Saunas

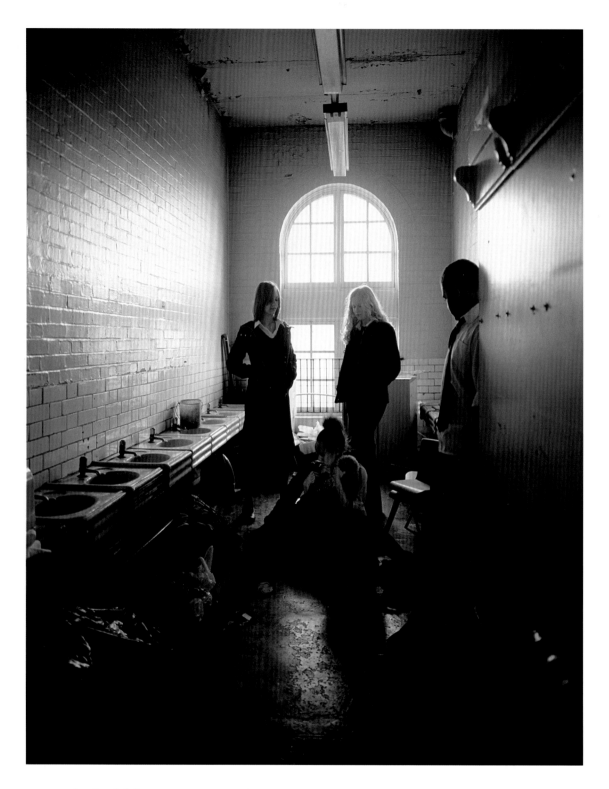

Gang Rape Ordeal

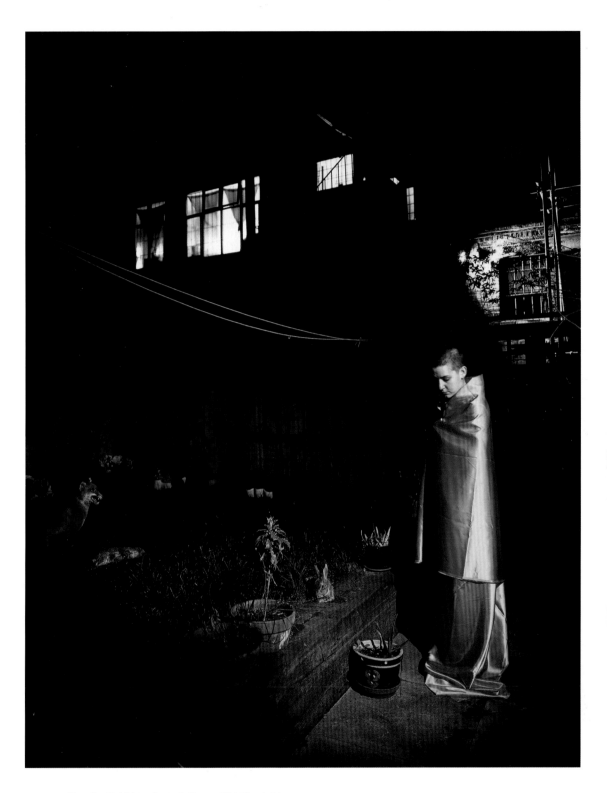

Bounding Buddhist rushes to the Rescue of Neighbour's Pets

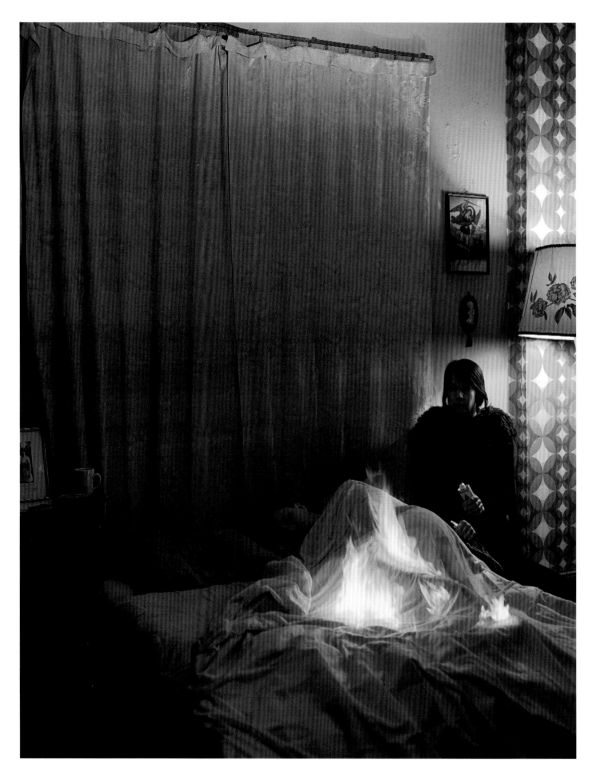

Lover set on Fire in Bed

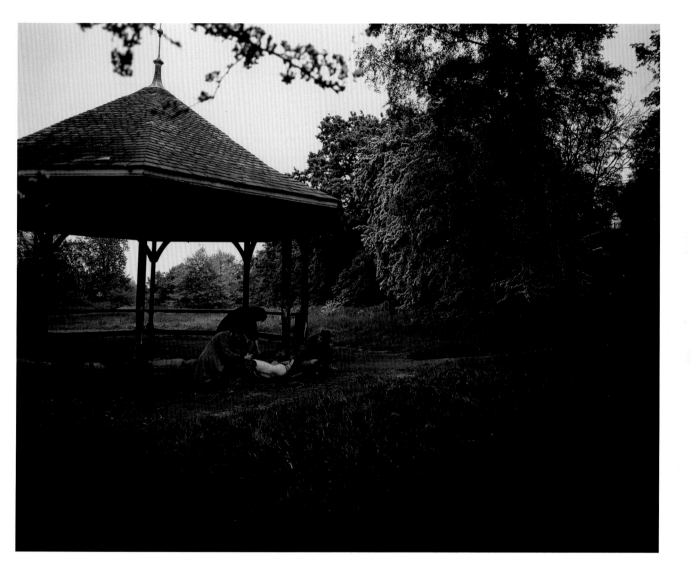

Sex Assault

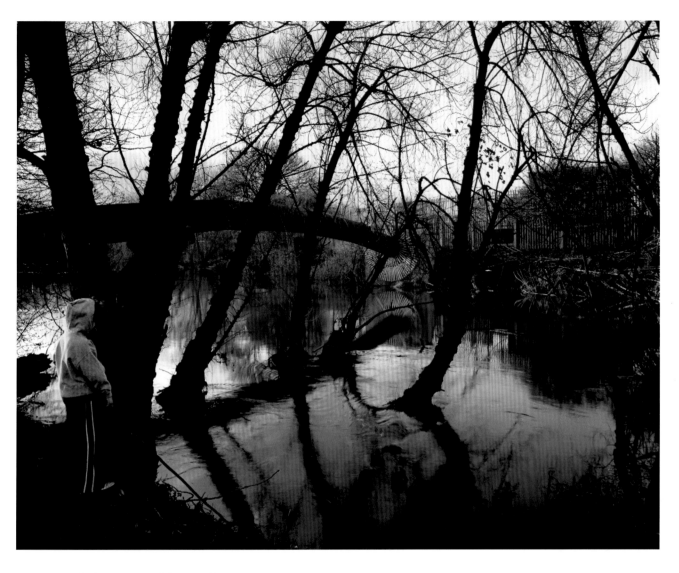

Gangland Execution. Boys find Man's Body in River

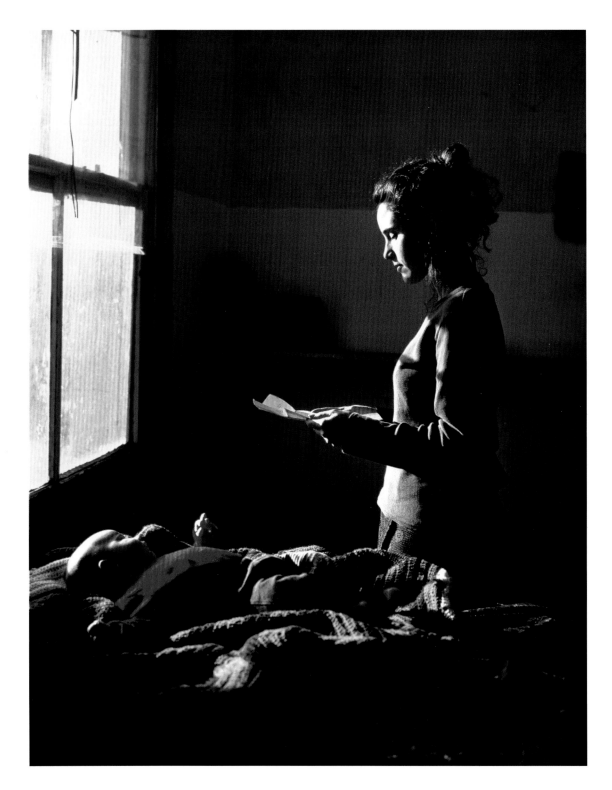

Woman reading a Possession Order

LIVING IN HELL AND OTHER STORIES

Colin Wiggins

TOM HUNTER is a storyteller. He tells his stories in carefully staged photographs that are printed on a large scale. They are then framed and displayed like Old Master paintings. Hunter's friends and associates appear in the pictures, performing the roles he assigns to them. They use gesture, body language and facial expression in the same way as the characters seen in paintings by the Old Masters, who act out their own stories in paint.

Indeed, a fair proportion of Hunter's works to date have been contemporary re-stagings of paintings from the past. Hunter works within the tradition of pictorial narrative but uses it to show us our own times. His photographs tell stories from his home environment of Hackney in the East End of London. What makes his work special is the way these stories are re-enacted. Commonplace, fleeting moments become serious meditations, something timeless and eternal, like ancient myths.

Hunter first came to public attention in 1998, when he won the John Kobal Photographic Portrait Award at the National Portrait Gallery, with a photograph entitled *Woman reading a Possession Order* (p.40). With its meticulously arranged composition and sensitively captured light, it is a direct and deliberate quotation of a painting by Vermeer, *A Girl reading a Letter by an Open Window* (fig.1). Indeed, Hunter produced a whole series of works, eight in all, collectively titled 'Persons Unknown', that transplanted Vermeer's masterpieces from seventeenth-century Delft to Hackney in 1997.

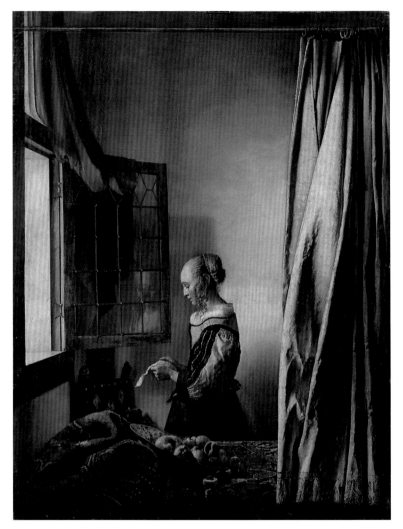

Woman reading a Possession Order uses Vermeer in two ways. First, there is the composition, with the woman seen in profile at a window, exactly mimicking the original painting. Secondly, it tells a story. Here, however, Hunter is departing from Vermeer and relating a narrative from his own time. Parts of Hackney are socially depressed and Hunter was at the time living in a series of squats, choosing fellow squatters and homeless travellers as his models. The room is bleak, the mood mournful. The title suggests that the young mother is about to be evicted. There is no hint of the baby's father, and we are left to speculate about the woman's

2.
John Everett Millais (1829–1896)
The Vale of Rest
1858–9
Oil on canvas
102.9 x 172.7 cm
Tate, London
N01507

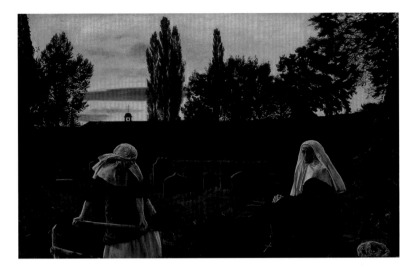

situation. She is not a specific, named individual but emblematic of a class of dispossessed people, victims of the economic and political circumstances of the time. Hunter's own history as a squatter leads him to sympathise with the people in the stories he tells.

To construct a work like this, Hunter needs to choose and direct his players, to select a location, add and arrange the props and then wait for the exact condition of light. Hunter replicates the formal composition of Vermeer's picture and on to this he hangs his own narrative, as meaningful to his own time as Vermeer's is to his.

The series 'Life and Death in Hackney' of 1999–2001, used paintings by the Pre-Raphaelites as its source. Once again, the characters in the photographs were taken from the local communities of travellers and squatters. *The Vale of Rest* (p.44) quotes both the composition and title from a painting by Millais (fig.2) and has the same golden light and autumnal glow. *The Way Home* (p.45) shows a woman with closed eyes lying on her back in a canal. She is paying a waterlogged tribute to Lizzie Siddal who famously modelled for Millais by lying in a full bathtub to represent the drowning of Shakespeare's suicidal heroine *Ophelia* (fig.3). In Hunter's response we puzzle over how this woman got into the canal: Is she alive? Does the link with Ophelia provide a clue? A definitive answer is tantalisingly unreachable. Even the artist's own admission that he was re-enacting a drunken accident that happened to a friend, does not satisfactorily explain this mysterious image.

The Vale of Rest

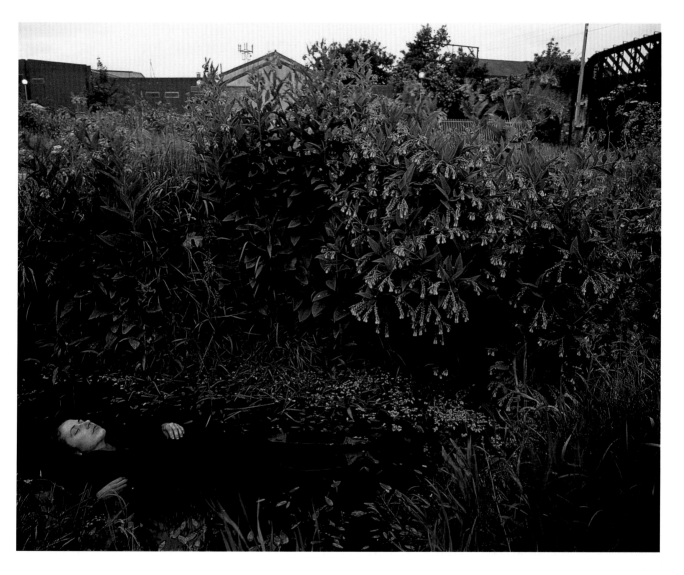

The Way Home

3.
John Everett Millais (1829–1896)
Ophelia
1851–2
Oil on canvas
76.2 x 111.8 cm
Tate, London
N01506

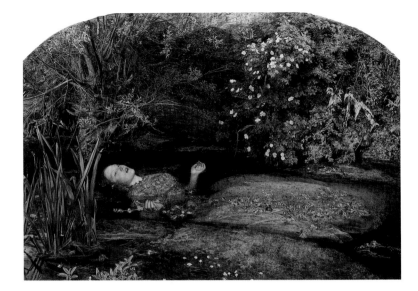

The 2001 series 'Public Houses' is a sequence of images shot in local pubs that are used for striptease performances. *The Dolphin* (p.48), with its barmaid gazing wearily from behind the counter, is unmistakably an echo of Manet's *A Bar at the Folies-Bergère* (fig.4). Both the painting and Hunter's photograph represent popular entertainment venues and share various incidental details, such as the play of light over the sparkling bottles. In the background of *The Dolphin* is a lone drinker, waiting for the performance to begin. A young woman walks by carrying two large feathered wings, which are props for her act. In Manet's painting the audience and the performer, whose legs are seen at the top left, play out their lives against a backdrop of modern Paris. Hunter's characters, direct descendants of Manet's, have their own modernity: life in contemporary Hackney.

Ye Olde Axe (p.49) is another strip-joint/pub, and Hunter uses it to produce a provocative burlesque based on Velázquez's *The Rokeby Venus* (fig.5). The shimmering mirrors framing the stage are strikingly similar to the background of *A Bar at the Folies-Bergère* but also provide a point of reference to the mirror in Velázquez's work. A sinister-looking man in black takes the place of Cupid. Venus is now a stripper wearing stilettos and a G-string. In her High Art context, Velázquez's Venus hangs safely on the wall of the National Gallery as one of the many nude goddesses who inhabit the classical myths. The shroud of history renders them

4.
Edouard Manet (1832–1883)
A Bar at the Folies-Bergère
1881–2
Oil on canvas
96 × 130 cm
The Samuel Courtauld Trust,
Courtauld Institute of Art Gallery,
London
P.1934.SC.234

5.
Diego Velázquez (1599–1660)
The Rokeby Venus
1647–51
Oil on canvas
122.5 × 177 cm
The National Gallery, London
Presented by the National Art
Collections Fund, 1906
NG 2057

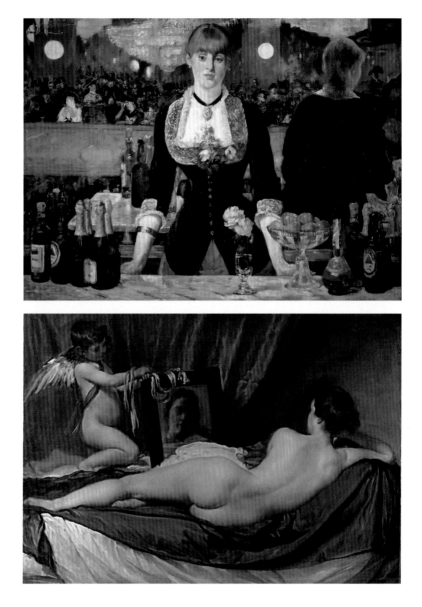

sweatless and sterile. Hunter's image removes that shroud and reclaims
Velázquez's masterpiece for what it is: a picture of a young, beautiful,
naked woman, displaying herself for the male viewer. The woman in
Hunter's picture, locked in her sleazy setting, is doing exactly the same.
The studio of Velázquez and a Hackney strip club are, for a moment,
connected, and remind us that context is everything.

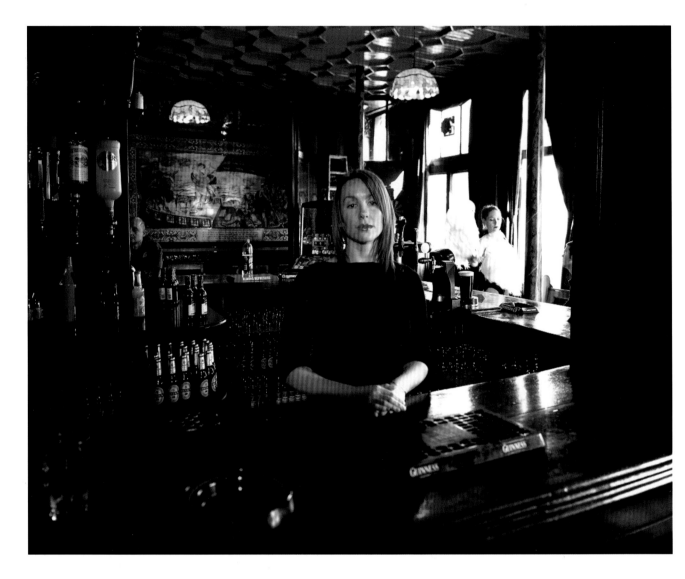

The Dolphin

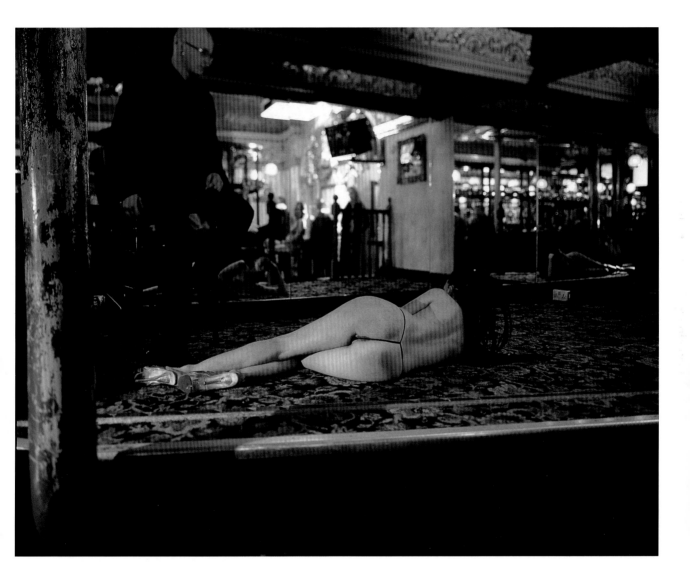

Ye Olde Axe

HEADLINES

Tom Hunter has lived in Hackney since the age of 21 and the series
'Headlines' continues his interest in those stories of inner-city life that
take place in his own locality. Even those compositions that do not refer
directly to paintings of the past still share certain features that bond
them closely to the conventions of art history. The stories they tell are all
taken from the *Hackney Gazette*. The idea of turning to his local press as a
source for inspiration was suggested by the example of Thomas Hardy.
Hardy, like Hunter, was born and brought up in Dorset and would trawl
through back copies of the *Dorset County Chronicle*, where he would find
those stories of public hangings, wife-selling and other unlikely events
that he could then use in his fiction.

 Hunter is not a photojournalist. His photographs are not literal
reconstructions of actual events. It is not the specific details of the story
that attract him, rather it is the idea of the story that is provoked by the
eye-catching headlines, often jokey, sensationalist or punning, that sub-
editors attach to the stories. We are never fooled into thinking that what
we are seeing is anything other than an artistic contrivance. We do not
need telling, for example, that a figure apparently lifeless on the ground
is not really dead, nor that someone lying prone surrounded by masked
figures has not really just been violently assaulted. They are posing in
the same way that studio models might work for a painter, or acting as
if on a stage. And in the same way we can suspend our disbelief when in
a theatre, Hunter allows us, just for a moment, to imagine that we are
witnessing reality, whether bizarre or prosaic, astonishing or ordinary.

Living in Hell
The story beneath the headline *Living in Hell* (p.21) told of a 74-year-old
woman, who had been left to live in damp, vermin-infested
accommodation condemned as unfit for human habitation. Hunter's
composition was made with the help of a retired actress and hundreds
of dead cockroaches, acquired via the Internet. These were painstakingly
arranged by the artist, to give the impression that they are alive. A
painting of around 1643, *Four Figures at a Table* (fig.6), by one of the Le Nain
brothers, was Hunter's point of departure. It shows a woman and her
family in a humble peasant interior. She has an expression that speaks
of a struggle to bring up her children but it is tempered with a quiet sense

6.
Le Nain Brothers,
Antoine (about 1600–1648),
Louis (about 1603–1648),
Mathieu (about 1607–1677)
Four Figures at a Table
About 1643
Oil on canvas
44.8 x 55 cm
The National Gallery, London
NG 3879

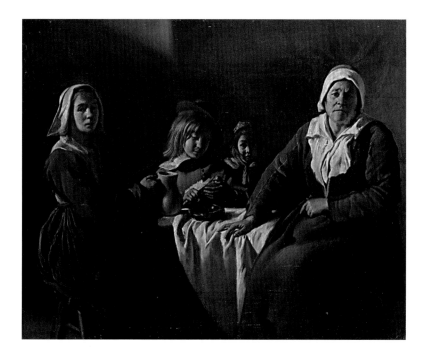

of self-respect. In Hunter's version of this composition, the family have
gone. The woman is abandoned. She sits wrapped up against the cold as
the electric heater glows dimly. The sofa is filthy and worn, there is
decaying food uneaten in its cardboard wrapping. A naked electric light
bulb illuminates the room and shows literally hundreds of cockroaches
crawling over every surface. This harsh illumination starkly reveals her
shocking fate. Cockroaches only emerge in the dark, so the implication
is that the light has only just, that very second, been switched on to reveal
the woman sitting in her dingy room, left alone and unloved. We can
imagine her a few moments earlier, shivering silently in the dark, while
all around her, the cockroaches creep. The Le Nains' dignified poverty
is ripped from its original seventeenth-century context and in 2004,
becomes brutally undignified.

Murder: Two Men Wanted
It is from the commonplace that we gather our archetypes. A young
woman – bright, attractive and popular – disappears. Her lifeless body
is found by a passer-by. Ever since there has been a popular press, such
stories have been reported with relish.

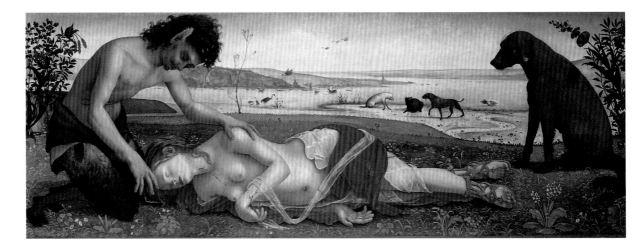

7.
Piero di Cosimo
(About 1462 – after 1515)
A Satyr mourning over a Nymph
About 1495
Oil on poplar
65.4 x 184.2 cm
The National Gallery, London
NG 698

The tale of unfulfilled youth destroyed by the bestial has found its way into every culture. Piero di Cosimo's *A Satyr mourning over a Nymph* (fig.7) depicts the body of a woman, her throat bleeding from a gash that has caused her death. A satyr has just discovered her and tenderly places his hand upon her shoulder. A similarly sad looking dog sits by. The precise meaning of this picture is unclear. Art historians have suggested that it might represent the story of Procris, killed by her hunter husband Cephalus, who mistook the sounds of Procris' movements in the forest for a wild animal. He threw his spear at where the sound was coming from and killed her. However, casting doubt on this interpretation is the fact that this tale does not include the satyr, who is clearly playing a significant role in whatever story is depicted here.

Despite the art historian's inability to identify this picture's precise subject, it is still supremely affecting. The painting is poignant, tender and above all, tragic. It works because it is telling us a story we already know. Not a precise and identifiable story with a good classical pedigree but an archetypal one.

Hunter's response to Piero di Cosimo's composition is a photograph that captures the same sense of stillness and serenity that is found in the painting. A young man echoes the gesture of the satyr by resting his hand on the prone figure of a young woman. A dog completes the cast of characters. The title of the work is taken verbatim from a headline, *Murder: Two Men Wanted* (p.31). These four brusque words were printed above a story that reported the murder of a young woman in a public

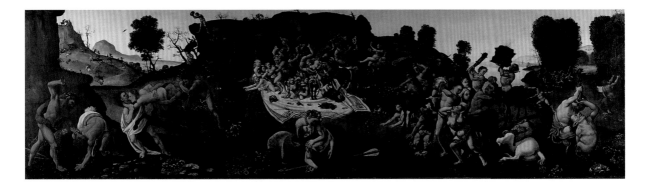

8.

Piero di Cosimo
(About 1462 – after 1515)
*The Fight between the Lapiths and
the Centaurs*
Probably 1500 – 15
Oil on wood
71 x 260 cm
The National Gallery, London
NG 4890

park. Two friends of Hunter with their dog, directed by the artist, acted out Piero di Cosimo's painting, thereby bringing together a timeless Renaissance painting with a vicious contemporary event.

The photograph, like the painting it depends upon, has an archetypal resonance of the tragic and premature end of youth and beauty. The night-time setting and the carpet of autumn leaves take on a symbolic meaning. The expression in the young man's body and face indicate bemusement, the same lack of understanding about how this can be happening that we all feel when this story is replayed yet again, with another innocent victim becoming just the latest in a endless list that goes back to classical times and beyond.

For Batter or Worse

Piero di Cosimo also provides the source for this image although this time the headline, *For Batter or Worse* (p.29), with its pun on the marriage vows, is whimsical, despite referring to a violent story of a brawl at a wedding. Piero di Cosimo's painting *The Fight between the Lapiths and the Centaurs* (fig.8) is a scene from a classical legend that describes how the centaurs, part horse and part human, were invited to a wedding by the human Lapiths. The centaurs, fuelled by drink, attacked their hosts. For his picture, Hunter chose a cast comprising of two distinct groups, redheaded and Far Eastern. He then arranged these people on the steps of Hackney Town Hall, a popular venue for wedding receptions. However, this wedding has gone terribly wrong and a free-for-all breaks out.

Hunter makes several direct quotations from Piero di Cosimo's painting: a kneeling woman tends to the stricken figure of an injured man; the woman in the red dress is having her hair pulled. Hunter refers

to the centaurs by including a pair of splendidly plumed horses, complete with carriage and attendants. Before the fight broke out, this wedding was clearly going to be a grand occasion but black horses, of course, also have funereal connotations.

In showing the fight as being between two distinct racial types, Hunter gives his scene a symbolism that goes beyond the simple retelling of a local story. This is not just the clash of two families at a wedding, it is a clash of cultures. Hackney is a diverse area and in casting his response to Piero's painting with redheads and Far Eastern, specifically Vietnamese, characters, Hunter is addressing the question of racism; the redheads might be seen to represent the native peoples of the British Isles, whilst the Vietnamese are the immigrants. Their different colour, faces and culture make them stand out and become objects of violence. The ancient legend and the contemporary story are plainly both examples of how misunderstandings between different groups of people can escalate into conflict. Hunter's photograph provides a powerful connection between myth and reality.

Hallowe'en Horror: Trick or Treat Thugs break Mum's Bones
Not all of Hunter's works have a direct compositional source. They do however, have that same sense of order that is found in classical painting. The title of this piece comes from a story reporting the violent assault of a woman on her own doorstep. Hunter's photograph shows a woman on the ground surrounded by a group of six masked and hooded men. It is set at night, with the principal source of illumination coming from the window and open door of the woman's flat. The low viewpoint gives the paving stones the same kind of perspective that is found in countless Renaissance paintings. Their vanishing point is exactly in the centre of the head of one of the attackers but this is no more than a coincidence. Also accidental is the resemblance to Caravaggio's *The Beheading of Saint John the Baptist* (fig.9). When composing his Biblical narratives, Caravaggio worked in the same way as a film or theatre director, directing his models to act out the drama he was representing. The practicalities of Hunter's art mean that he works in the same way. The figures in Caravaggio's painting hold their poses at the painter's instruction. It is the artist who decides where and how they stand, as

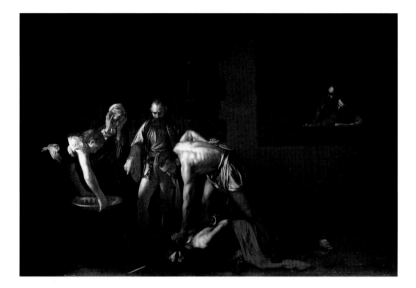

9.
Michelangelo Merisi da Caravaggio
(1571–1610)
The Beheading of Saint John the Baptist
1608
Oil on canvas
361 x 520 cm
Co-Cathedral of St John, Valletta,
Malta
BEN 127658

they re-enact this sacred, bloody drama. It is the same for Hunter. In *Hallowe'en Horror: Trick or Treat Thugs break Mum's Bones* (p.27) the six attackers are arranged symmetrically. They bend their heads towards the woman as she curls up into a foetal position. Gently bathed in the light from the open door, the composition takes on the aspect of some kind of mysterious ritual with a sacred, if violent purpose. A staged photograph prompted by a specific episode becomes an exemplar of the repeated stories of mindless inner-city violence that fill our newspapers. Although the resemblance to Caravaggio is accidental, the sense of classical order within the photograph is not. Hunter is exploiting a language of gesture and composition that we have come to understand in the serious context of Old Master painting.

Road Rage Thug jailed for Attack on Priest

A sense of geometrical order is often found in Hunter's work. The composition of *Road Rage Thug jailed for Attack on Priest* (p.32) is dominated by verticals and horizontals that are formed by the architectural features and street furniture. It is divided in two by a standing figure, whose placement is underpinned by the drainpipe and lamp post. This division tallies almost exactly with the Golden Section, the celebrated Euclidean proportion that became so important to Renaissance art and architecture. This was not calculated by Hunter, rather it was done by eye

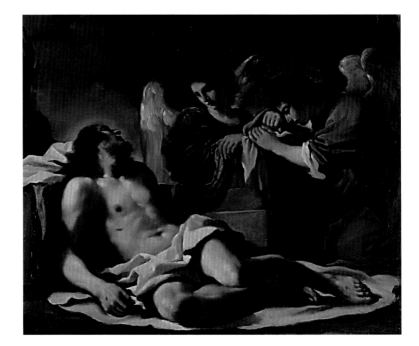

10.

Guercino (1591–1666)

The Dead Christ mourned by Two Angels

About 1617–8

Oil on copper

36.8 x 44.4 cm

The National Gallery, London

NG 22

and appears in several of his other compositions. Combined with the
directed, ritualistic poses of his actors, it emphasises the artifice of
Hunter's practice.

The source for this composition is Guercino's *The Dead Christ mourned
by Two Angels* (fig.10). The priest lies in the road and takes up the position of
Christ, while his burly crop-headed attacker stands over him. The setting
and its atmosphere are all important. The shot was taken from the other
side of the road, so the two players are seen in the distance. No one else
is about. The sense of menacing, bleak isolation is paramount and is
emphasised by a piece of litter drifting in the middle-distance. The light
descending from the solitary street lamp takes on a religious meaning,
especially when we notice that high up on the wall, obscured in shadow,
is a relief sculpture of the Crucifixion. It is only this feature that indicates
that the nondescript brick building, with its windows protected by
security grilles, is in fact an inner city convent, almost reluctant to admit
its true identity. Hunter chose this location exactly because of that
sculpture with its mourning figures, which provides an oblique link to
the angels of Guercino's painting, and his photograph becomes an
image of religious martyrdom translated to modern London.

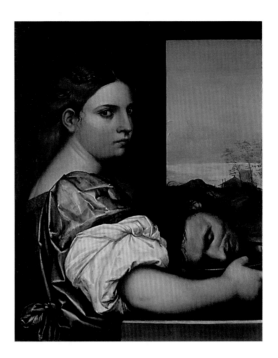

11.
Sebastiano del Piombo
(about 1485–1547)
The Daughter of Herodias
1510
Oil on wood
54.9 × 44.5 cm
The National Gallery, London
NG 2493

Lover set on Fire in Bed

The bedclothes of a sleeping man begin to burn. A young woman, who clutches a lighter and a can of lighter-fuel, looks out at us. She engages with our view directly, not trying to hide her crime; she wants us to see what she has done. The crumpled sheets and the indentation in the pillow hint that she has been in the bed: she must have crept out when her lover fell asleep. On the wall above her is a framed print of Saint Michael, wielding the scales of justice and slaying the dragon. A photograph by the bed shows a young girl. However, we do not see all of it. It looks as if there might be another person in this little photograph who has been symbolically severed by the edge of the composition.

The spurned lover's revenge is classic tale from every period and every culture. The history of Western art boasts many pictures showing how the guiles of women can destroy powerful men. Samson and Delilah, Judith and Holofernes, or Salome and Saint John the Baptist are among the most popular. Stories of duped male victims and conspiratorial women have been used moralistically, humorously, as exemplars or warnings. Hunter's *Lover set on Fire in Bed* (p.36) adds to that tradition. The sleeping man is covered by the bedclothes so we only see

12.
Peter Paul Rubens (1577–1640)
Samson and Delilah
About 1609–10
Oil on wood
185 x 205 cm
The National Gallery, London
NG 6461

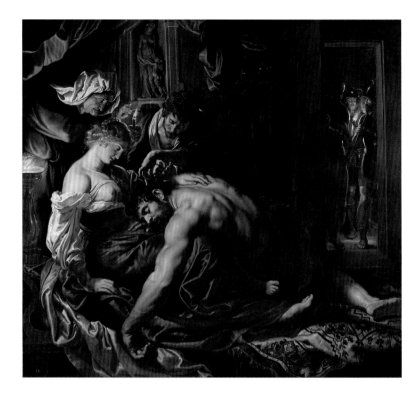

his head, a carefully arranged pun on the many painted images of severed
heads triumphantly displayed by Salome or Judith. Sebastiano del
Piombo's *The Daughter of Herodias* (fig.11) is only one of a number of National
Gallery paintings to which *Lover set on Fire in Bed* relates. Rubens's *Samson
and Delilah* is another (fig.12). The act of betrayal carries a burden for
Delilah. She looks down at her sleeping lover with pity and tenderness,
something akin to regret. Hunter's woman communicates a similar
sense of poignancy. Indeed, she makes no attempt to escape, as if she
wishes herself to be consumed by the flames as well as her victim. If this
is the end for him, it is the end for her as well. The closed curtains add
to the sense of finality in a work that is a lament for lost love.

Naked Death Plunge
The London Borough of Hackney is blighted by tower blocks, thrown
up in the 1960s to replace the bulldozed slums or blitzed buildings
that had once been homes to thousands. The tower blocks were a
disastrous social experiment, with occasional trees and patches of grass

13.
Sebastiano del Piombo
(about 1485–1547)
Death of Adonis
1511–2
Oil on canvas
189 x 285 cm
Galleria degli Uffizi, Florence
K110006

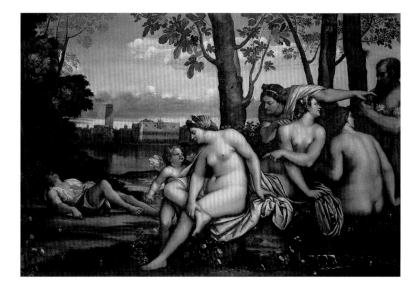

optimistically designed to provide pleasant common areas for tenants to socialise, picnic and otherwise relax.

One of these green spaces provides the setting for *Naked Death Plunge* (p.28). This work refers to a detail of Sebastiano del Piombo's *Death of Adonis*, a sixteenth-century mythological painting that is now in the Uffizi, Florence (fig.13). The position of Hunter's figure is borrowed directly from Sebastiano's representation of Adonis. Hunter was attracted to this painting by the appearance of Venice in the background as an unlikely location for the myth. As the distant towers of Sebastiano evoke Venice, so does Hunter's tower block symbolise Hackney. His figure is not, of course, Adonis but is derived directly from the headline, *Naked Death Plunge*. There are no clues in the picture about the exact story. The vertical format of the image, with the figure seen lying prone beneath a succession of balconies, implies that he has fallen from high up, in some kind of replaying of the Icarus myth. Although set at dusk, there are very few lights showing from the building, except from what is presumably a stairwell. Like the recurring balconies, the stairwell windows provide another repeated vertically-orientated pattern that suggests the downward plunge of the body. The figure's nakedness, together with the abandoned football, hint at some bizarre happening in the prosaic location of a grubby patch of grass alongside a brutally functional piece of architecture.

14.
Paul Gauguin (1848–1903)
Spirit of the Dead Watching
1892
Oil on burlap mounted on canvas
92 x 113 cm
Albright-Knox Art Gallery, Buffalo,
New York
A. Conger Goodyear Collection, 1965
INV. 1965

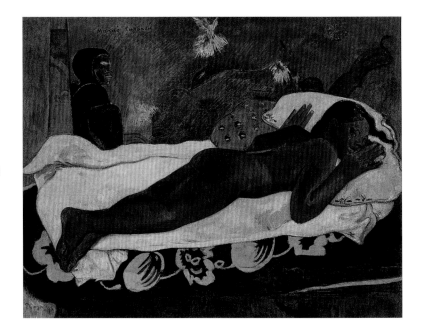

Rat in Bed
A young Asian woman, two rats and a cat play the roles in a work based
on the headline *Rat in Bed* (p.23). In a room that is predominantly pink,
the curtains are drawn and the bedside lamp is on. A gold lamé clutch-
bag and an ostrich egg are seen on the bedside table, alongside a bottle in
which an ostrich feather has been placed. Adding to this hint of
exoticism is a picture of the Hindu elephant god Ganesh that hangs on
the wall. The Chinese-styled fairy lights, strung along the brass bedhead,
add to the atmosphere which provokes questions about the profession of
the woman and the purpose of the room. On the floor, there is a neat line
of footwear, which includes a pair of stack-heeled leather boots and
fluffy stilettos. They apparently belong to the woman, but no other
clothes are visible. She lies naked on the crumpled bed, apparently
asleep, her luxuriant hair flowing along her body. A cat is sprawled on the
rug, also asleep. Neither the woman nor the cat is aware of the two rats.

 Gauguin's iconic *Spirit of the Dead Watching* (fig.14) provides Hunter with
his composition. Gauguin himself explained this picture. The figure on
the left represents the ghost of an ancestor of the young Tahitian girl.
She believes that it can see her and she is frightened. Gauguin's exotic
imagery carries a powerful sexual charge, and the nature of his

relationships with very young Tahitian women scandalised the island's colonial administration. Hunter's re-enactment confronts various issues. Taking his cue from Gauguin, Hunter uses a model who can be perceived as exotic. Many young women from poor backgrounds in present day Asia are exploited by the sex trade and provide fodder for Western European sex tourists. They are trafficked into European cities where they are cruelly exploited. The young Asian woman in Hunter's picture sleeps, while the sumptuous swirls of the poppies that decorate the pillow perhaps hint at an escape that she can only reach in her dreams. Her reality is different. The two rats of which she is, for the moment, blissfully unaware, scuttle across her bed. They are part of the squalid environment and decadent culture that defile her, and symbols of the Western men who visit her in her room.

Nun tears Strip off Club Client
This startling image is set in a pub and shows a nun brandishing a statue of the Virgin Mary (p.26). The nun is glowering at a sheepish-looking man who pretends to ignore her by staring into an empty glass. In the background is an exotically clad young woman who wears white thigh-length boots and a skimpy red minidress that reveals her underwear.

Taken in conjunction with the title, it is apparent that the young woman provides entertainment to the club's male clientele by stripping. The fervent expression of the nun, in her severe black garb, makes a splendid contrast with the quizzical look on the stripper's face. Both of these women reveal their characters by their clothing: Hunter is using the classic theme of saints and sinners. Throughout the history of art, and indeed throughout the history of the Christian religion, women have often been stereotyped as belonging to either one or other of these categories. It is clear that the nun has come between the entertainer and her client but it is the man she berates, not the woman.

The statue the nun holds was chosen by Hunter because of its close resemblance to *The Immaculate Conception* by Velázquez (fig.15). Painted in Seville in about 1618, its original purpose was devotional. It is easy to forget that a painting like this was not made to display in an art gallery but was conceived as an aid to religious contemplation. The nun is using her image of the Virgin not as a work of art but as a spiritual weapon

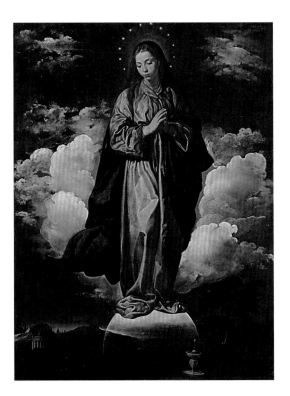

15.
Diego Velázquez (1599–1660)
The Immaculate Conception
About 1618
Oil on canvas
135 × 101.6 cm
The National Gallery, London
Bought with the aid of the National
Art Collections Fund, 1974
NG 6424

and as such reminds us that we cannot fully understand the Velázquez painting unless we admit its original context.

The empty glass held by the young man stands as a metaphor for the spiritually empty transaction that he has come to the club to enjoy. Immediately above his head is an advertisement for Guinness showing a full glass that is, significantly, out of his sight. Amusingly, its black and white form closely matches the nun's habit. Follow the advice of the nun, it seems to say, and your glass will be full.

Up Before the Beak: Angry Swan guards Bridge after Crash
This ridiculous headline, attached to a story of how an angry swan attacked a woman on a bridge, inspired Hunter to produce one of his oddest photographs (p.25). Although there is no direct Old Master source, it is in effect a classical landscape in the manner of Claude. The dark trees at the top lead us into the picture. Everything is perfectly still and tranquil. The water reflects the beautiful autumn glow of the sky. On a path that leads up to a bridge, a woman lies on her back. She is

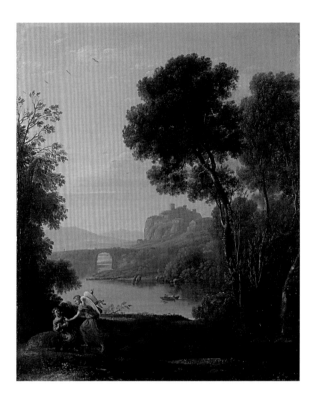

16.

Claude (1604/5–1682)
Landscape with Hagar and the Angel
1646
Oil on canvas mounted on wood
52.2 × 42.3 cm
The National Gallery, London
NG 61

dishevelled, one of her white shoes has come off and her legs are spread apart. On top of her is a swan. This unexpected event, combined with the very ordinariness of the setting, makes a powerful contrast. Because of their distance into the picture space, the woman and the swan are relatively small, exactly like the figures in one of Claude's idyllic landscapes, in which they enact various Biblical or mythological stories. The National Gallery's *Landscape with Hagar and the Angel* (fig.16) makes a good comparison, with the story apparently taking second place to the beautiful light illuminating the poetic landscape.

Hunter has produced a contemporary Claudian landscape, cool and serene, in which we find a twenty-first-century Leda and the Swan. This myth describes how Jupiter, in order to seduce Leda, changed his form into that of a swan. His ruse was successful and Leda's four children were hatched from the eggs she laid following her union with the god. This story has frequently been represented throughout the history of art, from antiquity onwards, with varying degrees of explicitness. For example, following its acquisition in 1838, a copy after

17.
After Michelangelo (1475–1564)
Leda and the Swan
After 1530
Oil on canvas
105.4 × 141 cm
The National Gallery, London
NG 1868

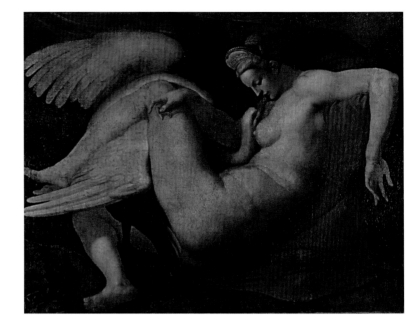

a lost painting by Michelangelo was deemed by the National Gallery to be too indecent for public display (fig.17).

Hunter follows this precedent. Despite their distance into the picture space, it seems apparent that the swan and the woman in his image are fully re-enacting this curious myth. When represented in an Old Master painting, the idea of a woman and a swan coupling in the balmy evening light is accepted as pastoral and poetic. In a photograph it becomes disquieting and bizarre.

Girls' Sex Acts in Club: Court. Cop: 'It can only be described as having Sex through Clothes'
The stage, the curtains and the lighting leave little doubt that this is a strip-club. Hunter's source for this photograph (p.24) is one of the most sexually provocative paintings in the National Gallery, Cranach's *Cupid complaining to Venus* (fig.18). The goddess of love is in the forest, wearing an elaborately impractical hat, a gold choker and nothing else. Cupid has stolen a honeycomb from the tree and is stung by the bees for his pains. He looks towards his mother for some sympathy but receives none because she is too busy attempting to titillate the viewer. She looks out of the picture with her seductive half-closed eyes and indecently strokes

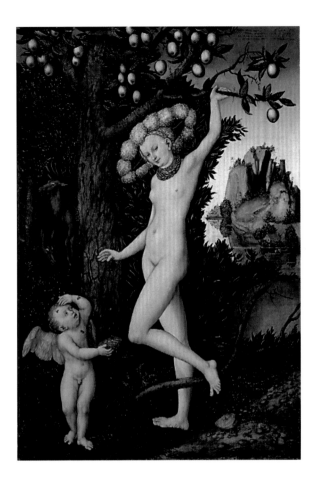

18.
Lucas Cranach the Elder (1472–1553)
Cupid complaining to Venus
About 1525
Oil on wood
81.3 x 54.6 cm
The National Gallery, London
NG 6344

her foot against the branch that she straddles, while suggestively holding onto another branch above her head. It is an absurd and erotic parody of a picture. Hunter continues the spirit of parody. A naked stripper, wearing only a choker and earrings, adopts the flagrant pose of Venus. A clothed man rests his head on the white, feathered fans used by the stripper in her performance, a neat allusion to the feathers of Cupid's wings in the Cranach painting.

The stripper herself provides a further twist that adds to the allusive nature of the image. At a given moment in her act she crouches down, parts her swan wings and apparently lays an egg that she been concealing inside herself. Both artist and stripper are fully aware of the reference to the myth of Leda, who laid her own eggs after her seduction by Jupiter in his swan guise. Furthermore, in the amphitheatres of ancient Rome,

public spectacles used to include the grotesque enactments of myths, with captive women forced to simulate copulation with those animals whose form Jupiter took during his amorous escapades. It is both surprising and thought-provoking to find a strip-joint in Hackney working within such scholarly frames of classical reference.

The headline refers to court proceedings where a police officer was giving evidence. Consequently we can understand that the man at the stripper's feet is a police officer, attempting to accumulate evidence for a prosecution. The undercover policeman who finds himself in a compromising situation is a staple of English humour. He is undoubtedly in this seedy club 'all in the course of duty, your Honour' and it would be unfair to misinterpret his intentions. Similarly, it would be unfair to doubt the motives of the original patron of Cranach's painting, obviously an erudite connoisseur who wished to satisfy his interest in classical myth.

Father and Son run £2m Vice Racket from Saunas
Some headlines are ambiguous or suggestive, others are witty, comical or sensationalist. This one however, is about as plain-speaking as possible. Hunter's interpretation shows two men sitting amongst a group of eight scantily and sexily clad young women, in a room whose purpose is clear. This is a brothel scene. Hunter's direct source for his photograph (p.33) is Ingres's extraordinary *The Turkish Bath* (fig.19). Less directly, it also carries echoes of pictures such as Picasso's *Demoiselles d'Avignon*, Degas's brothel monoprints, Delacroix's *Women of Algiers* and other Orientalist images by artists as diverse as Gérôme or Renoir.

Within the history of art, the female figure either nude or, as here, very nearly nude, has been one of the foundation stones of the European tradition. In earlier centuries a depiction of near-naked beauties might well have been given a mythological disguise, such as Diana and her nymphs. By the time of Ingres, the interest in things oriental had become the justification. Ingres's painting represents a harem of sensuous women, oiled and perfumed, languidly awaiting the summons of their owner. It is an unfettered vision of eroticism and decadence that catered for Western fantasies. Orientalism is a concept that has been the subject of much recent debate which has centred upon attitudes to gender and

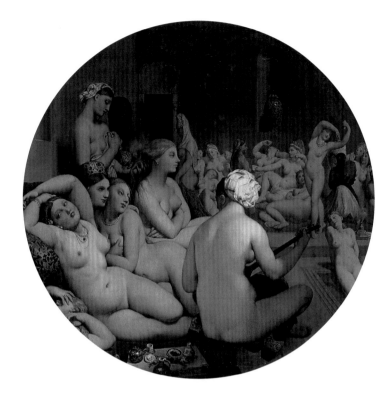

race. Like both Degas and Picasso before him, Hunter takes Ingres's harem and transplants it to his own time, where it becomes a brothel. The costumes of the women, the parlour palm and the hookah in the corner, all help to forge the link with Ingres's Orientalist vision. With the inclusion of the two men in his photograph, Hunter addresses these issues of exploitation, as well as tackling full-on the subject of prostitution. His picture is not simply an updated version of Ingres's painting. By showing these beautiful young women displaying themselves for the viewer's pleasure, yet who are simultaneously symbolising abuse and exploitation, Hunter is also producing a critique of the whole tradition of the classical female nude within which Ingres was working.

Sex Assault

Hackney is no different to many other inner city boroughs and has its share of sex assaults that all seem to merge with one another. But each nameless statistic is an individual whose body is abused and whose life

20.
Nicolas Poussin (1594–1655)
The Triumph of Pan
1636
Oil on canvas
135.9 x 146 cm
The National Gallery, London
Bought with contributions from the
National Heritage Memorial Fund and
the National Art Collections Fund, 1982
NG 6477

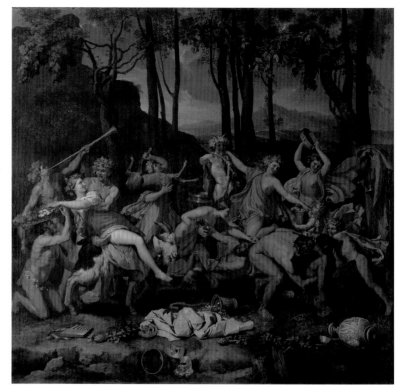

is brutally affected. Hunter's *Sex Assault* (p.37) could refer to any of these incidents but also generically to each one. Its pictorial source is a painting by Poussin, *The Triumph of Pan* (fig.20). This is a seventeenth-century representation of an ancient rite that depicts naked and semi-naked initiates dancing in front of a statue of Pan, a god of nature and fertility, whose face is painted bright red for the occasion. Poussin uses a piece of drapery to conceal that part of the sculpture that would otherwise frankly indicate the sexual nature of the dance. Hunter extracts a detail of Poussin's picture from the right foreground, where an unconscious drunken satyr is being supported by a naked man, whilst other revellers look on. This grouping provides a kind of template for the characters in Hunter's photograph who are acting out a scene in a deserted park, beside an old bandstand. Three men are forcibly pulling off the clothes of a fourth. It is a fairly grey day, which perhaps explains why there is no one else about. The eerie lighting adds a strangely magical atmosphere. Bandstands were once centres of social activity but

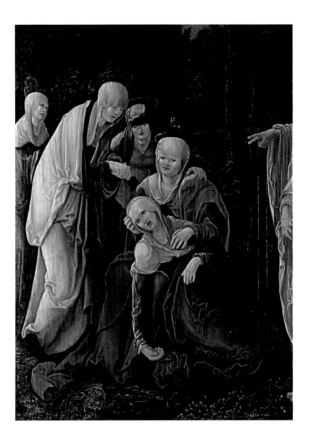

in contemporary Hackney, and indeed elsewhere throughout London, they have been left crumbling, abandoned to vandals.

Like Hunter's *Up Before the Beak*, the composition is balanced like a Claudian landscape. This similarity is reinforced by the cool green tonality and the relative scale of the figures. Rapes are commonplace in classical mythology and are often depicted by Poussin and Claude. They are also commonplace in our inner cities and Hunter's use of the subject, wrenches it from the safety of legend and thrusts it firmly in our faces.

Gang Rape Ordeal

A horrible title indicates a horrible event. Surprisingly, the composition is referencing Wolf Huber's *Christ taking leave of his Mother* (fig. 21), a picture that survives only as a fragment. Christ is departing although his image is almost completely severed from what survives of the picture. Only his extended hand, as he gestures farewell to his mother, is visible at the

right edge. In response to the news of her son's departure, the Virgin collapses, while family and friends try to offer their support.

Hunter subverts Huber's painting: the characters that surround the prone figure in his composition are not offering solace but instead look hostile and threatening (p.34). In Huber's painting the central figure is a virgin, whereas in Hunter's she is a rape victim. She is traumatised and clutches a coat against her body, as if she is trying to conceal her shame. However, she receives no sympathy from her companions, only contempt. The room itself is a soulless communal washroom with little child-sized sinks that perhaps indicate the setting is a school. Everything about it is harsh and unappealing. A sense of claustrophobia is reinforced by the narrowness of the room and the low viewpoint, which gives the picture a Renaissance-style perspective. Even the light that floods in through the window is cold and unforgiving, as it glares against the painted brickwork. This is one of the bleakest of Hunter's images and has none of the lushness of colour that characterises his other work.

Extreme violence and physical abuse abound on the walls of the National Gallery and other comparable collections. However, the patina of time and the High Art context renders it no longer shocking. Hunter's willingness to confront such brutal contemporary acts, and to realise them dispassionately and starkly, makes him into a chronicler of our times who connects with traditions of realist literature as much as with the history of painting.

Bounding Buddhist rushes to the Rescue of Neighbour's Pets
This whimsical headline has enabled Hunter to produce one of his most richly coloured and visually appealing photographs (p.35). Ludovico Carracci's *The Vision of Saint Francis* (fig.22) is the source painting. It shows the Virgin Mary appearing to Saint Francis and allowing him to cradle the infant Christ. She emphasises her heavenly nature by standing on a little bank of clouds that gently billows out. Seen in the background, beneath the starry moonlit sky, is the friar who witnessed and reported upon this miraculous event. Hunter extracts the Virgin from the composition and changes her identity, as he did with *Gang Rape Ordeal*. This time however, the subversion is rather gentler, as she is turned into a placid Buddhist monk wearing a robe of brilliant orange. The setting, as in the source

22.
Ludovico Carracci (1555–1619)
The Vision of Saint Francis
About 1583–6
Oil on canvas
103 x 102 cm
The National Gallery, London
On loan from the Rijksmuseum,
Amsterdam
L 991

painting, is night. The monk stands in a fenced backyard, hemmed in by tatty buildings. The light shining on the brickwork behind him functions as a surrogate halo. In front of him is a rabbit sitting, whilst a snarling fox looks on. Another rabbit is on the ground in front of the fox, although this one is mangled and dead.

The rabbits are, of course, the pets in the title. Although the monk is too late to save one, his intervention has rescued the other. The fox is stopped in its tracks by this unexpected apparition of serenity and beauty: the wild and savage is tamed by the spiritual. The fox in the garden indicates that even in an urbanised environment, nature still thrives. The washing line, with its single peg, adds a commonplace element that stands in complete contrast to the appearance of the monk, so out of place in an inner city backyard. Hunter has staged a miraculous, yet slightly ridiculous, vision in the unremarkable surroundings of Hackney.

23.
John Constable (1776–1837)
Stratford Mill
1820
Oil on canvas
127 x 182.9 cm
The National Gallery, London
NG 6510

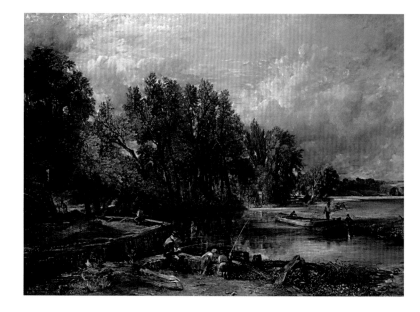

Gangland Execution. Boys find Man's Body in River
This is another pastoral landscape with no specific Old Master source. However, with its trees, water and reflections, it is close to the English landscape tradition as represented by a painting such as Constable's *Stratford Mill* (fig.23). This is one of several of Constable's Suffolk paintings that depict what was then thought of as a dull and uninspirational landscape. It had no historic meaning or literary associations with the heroic past and it was inhabited by characters felt by many critics of the time to be unsuitable subjects for art: farm labourers, bargemen or, as in *Stratford Mill*, young boys fishing.

Like Constable's Suffolk, the landscape of Hunter's Hackney is unprecedented as a subject for art. Yet even Hackney has its beauty. Areas of parkland or uncultivated patches of ground alongside canals can become colonised by plants and wildlife. As Hunter amply demonstrates, even Hackney is occasionally visited by beautiful sunsets and glowing skies that can make it appear idyllic. It can be framed to respond not just to the English landscapes of Constable but also, like *Gangland Execution. Boys find Man's Body in River* (p.39), to the classical compositions of Poussin.

Poussin's *Et in Arcadia Ego* (fig.24) shows a group of shepherds in ancient Greece who, despite their idyllic surroundings, discover a tomb inscription, reminding them that death is ever present. 'Et in Arcadia

24.
Nicolas Poussin (1594–1665)
Et in Arcadia Ego
1637–9
Oil on canvas
121 x 185 cm
Musée du Louvre, Paris
INV 7300

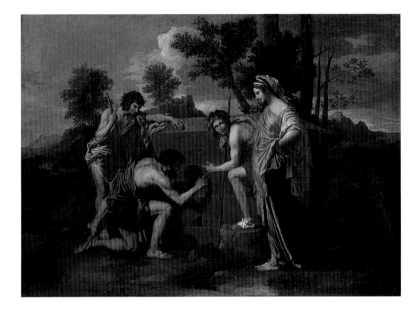

Ego', it reads, *Even in Arcadia, I am*. The boy of Hunter's photograph, carelessly playing by the river, makes his gruesome discovery and is suddenly hit by the same conclusion. As such, he becomes a pictorial cousin not just to Constable's fishing boys, but also to the classical shepherds of Poussin. With its beautiful mellow light, tranquil atmosphere and floating murder victim, the title of Hunter's photograph might well be approximated into Latin as 'Et in Hackney Ego'.

LIST OF WORKS

'Headlines'

p.21 *Living in Hell*, 2004
121.9 × 152.4 cm

p.23 *Rat in Bed*, 2003
121.9 × 152.4 cm

p.24 *Girls' Sex Acts in Club: Court. Cop: 'It can only be described as having Sex through Clothes'*, 2003
152.4 × 121.9 cm

p.25 *Up Before the Beak: Angry Swan guards Bridge after Crash*, 2003
152.4 × 121.9 cm

p.26 *Nun tears Strip off Club Client*, 2004
121.9 × 152.4 cm

p.27 *Hallowe'en Horror: Trick or Treat Thugs break Mum's Bones*, 2003
121.9 × 152.4 cm

p.28 *Naked Death Plunge*, 2003
152.4 × 121.9 cm

p.29 *For Batter or Worse*, 2005
121.9 × 152.4 cm

p.31 *Murder: Two Men Wanted*, 2003
121.9 × 152.4 cm

p.32 *Road Rage Thug jailed for Attack on Priest*, 2004
121.9 × 152.4 cm

p.33 *Father and Son run £2m Vice Racket from Saunas*, 2005
121.9 × 152.4 cm

p.34 *Gang Rape Ordeal*, 2003
152.4 × 121.9 cm

p.35 *Bounding Buddhist rushes to the Rescue of Neighbour's Pets*, 2005
152.4 × 121.9 cm

p.36 *Lover set on Fire in Bed*, 2003
152.4 × 121.9 cm

p.37 *Sex Assault*, 2004
121.9 × 152.4 cm

p.39 *Gangland Execution. Boys find Man's Body in River*, 2003
121.9 × 152.4 cm

p.40 *Woman reading a Possession Order*, 1997
From the series 'Persons Unknown'
Cibachrome print
152.4 × 121.9 cm

p.44 *The Vale of Rest*, 2000
From the series 'Life and Death in Hackney'
Cibachrome print
121.9 × 152.4 cm

p.45 *The Way Home*, 2000
From the series 'Life and Death in Hackney'
Cibachrome print
121.9 × 152.4 cm

p.48 *The Dolphin*, 2003
From the series 'Public Houses'
121.9 × 152.4 cm

p.49 *Ye Olde Axe*, 2002
From the series 'Public Houses'
121.9 × 152.4 cm

All works are Lambda prints unless otherwise stated

All works courtesy the artist and Jay Jopling / White Cube, London

BIOGRAPHY

1965
Born Bournemouth, Dorset

1980
Leaves school aged 15 and works on a farm for a year,
 and then for the Forestry Commission

1986
Moves to Hackney and works as a tree surgeon
Spends a year working for the USA Forestry Service in
 Puerto Rico

1990
Attends A-level Photography evening classes at Kingsway
 College, London

1991–1994
London College of Printing, BA

1997
Royal College of Art, MA

Currently lives and works in London

SOLO EXHIBITIONS

2005
Tom Hunter, Galeria Visor, Valencia

2004
Tom Hunter 1997–2004, Domus Artium 2002 Museum,
 Salamanca

2003
Tom Hunter, Yancey Richardson Gallery, New York
Tom Hunter, Frans Hals Museum, Haarlem

2002
Thoughts of Life and Death, Manchester Art Gallery,
 Manchester
Tom Hunter: Photographs, Contemporary Art Centre, Vilnius

2000
Life and Death in Hackney, White Cube, London; Green on
 Red Gallery, Dublin

AWARDS

2004
Residency at the Irish Museum of Modern Art, Dublin

2003
John Kobal Book Award

1998
John Kobal Photographic Portrait Award

1996
Royal College of Art First Year Award for Best Photography
 (Fuji Film UK Ltd)

1995
The Tredou Arts and Culture Awards

GROUP EXHIBITIONS

2005
Foreign Affair, Center for Photography at Woodstock, Woodstock

2004
Reanimation, Kunstmuseum Thun, Thun
Identity II, Nichido Contemporary Art, Tokyo
Really True! Photography and the Promise of Reality, Ruhrland Museum, Essen
Borne of Necessity, Weatherspoon Art Museum, Greensboro

2003
Turin Biennial of Photography, Turin
Photo London, Photographers' Gallery, London
Einblicke In Privatsammlungen, Museum Folkwang, Essen

2002
John Kobal Photographic Portrait Award 2002: A Celebration, National Portrait Gallery, London
Out of Place: Contemporary Art and the Architectural Uncanny, Museum of Contemporary Art Chicago; Samuel P. Harn Museum of Art, University of Florida, Florida
Tableaux Vivants, Kunsthalle Wien, Vienna
True Fictions, Kunsthaus Dresden, Dresden; Kunstverein Lingen, Lingen; Ludwig Forum, Aachen
The Rowan Collection: Contemporary British and Irish Art, Irish Museum of Modern Art, Dublin
Malerei Ohne Malerei, Museum der bildenden Künste, Leipzig

2001
Artists' London: Holbein to Hirst, Museum of London, London
Looking With/Out, Courtauld Institute of Art, London
Composure: Didier Courbot, Tom Hunter, Andrew Reyes, Susan Hobbs Gallery Inc, Toronto
Dana Hoey, Tom Hunter, Adam Baer, Fifty One Fine Art Photography, Antwerp
Experience Dissolution, Göteborgs International Konstbiennal, Konsthallen Göteborgs, Gothenburg
In a Lonely Place, National Museum of Photography, Film & Television, Bradford

2000
Look Out. Artists' Reactions to Contemporary Social and Political Events, Wolverhampton Art Gallery, Wolverhampton; Bluecoat Arts Centre, Liverpool; PM Gallery & House, Ealing; Ipswich Museum of Art, Ipswich
Residual Property. Tom Hunter, Mary Maclean, Jason Oddy, Elisa Sighicelli, Portfolio Gallery, Edinburgh
Breathless! Photography and Time, Victoria & Albert Museum, London

1999
Modern Times II. Residence, Erna and Victor Hasselblad Foundation, Gothenburg
Neurotic Realism (Part Two), The Saatchi Gallery, London
Semi-Detached, The Pump House Gallery, London

1998
Les Anglais Vus Par Les Anglais, Rencontres Internationales de la Photographie D'Arles, Arles
Campaign Against Living Miserably, Royal College of Art, London
Whitechapel Open, The Tannery, London

1997
Summer Show, Royal College of Art, London

PHOTOGRAPHIC NOTE

Tom Hunter uses a Wista 45 Technical Camera with both standard and wide-angle lenses. He uses Fujicolor reversal film for 8.96 x 12.7 cm transparencies.

The transparencies are then digitally scanned into high resolution files which are used to produce the Lambda prints.

Hunter always tries to use only the available light but will occasionally use a tungsten studio light for some shots.

The photographs are printed in New York at Laumont Photographics Inc., to a size of 121.9 x 152.4 cm. These are then mounted and framed in London.

ACKNOWLEDGEMENTS

Fela Adebigi
K. Alan
Roland Ariuze
Shereece Arnold
Phil B
Sophie Banyard
Brada Barassi
Camille Bensoussan
Cicely Blalock
Ryan Board
Joe Borrow
Rachel Bower
Katya Boyes
Irene Bradbury
David Bright
Faye-Marie Britton
Julie Brown
Ian Burke
Garreth & Saskia Burr
Fei-Ting Chang
Kelly Charlery
Becca Chester
Ellory Chester
Tracy Chevalier
Frederica Ciancetta
Tamara Clincik
Nick Cook
Jane Cranstone
Adam Crawford
Stephen Crothers
Franca Cusula
Bruno Davey
Charlie Dawson
David Delplanche
Mike Dickerson
Kim Van Dooren
Doug Dougal
R. Duf

Scot Duman
Rachel Dyer
Steve Farrant
Valentina Fernald
Aila Floyd
Jasmine Ford-Ellgood
Everest
Valentina Franzetti
Vince Gayle
Nina Gilbey
Andrew Graham
Sophie Greig
Lewis Griffin
Teddy Gutteridge
Gabrielle Hajdikova
Duncan Harbour
Louise Hayward
D. Hemmings
Graham Holman
Ashraf Husain
Jitka Hynkova
Imogen
Shigetu Ishihara
Jay Jopling
Karli
Magda Keaney
George Kiernan
Josh Kilbride
Kittie Klaw
Toshie Kurata
Janine Lai
Michelle Lauricourt
Natalie Lazarus
Dave Lee
Young Lee
Sophie Lees
Harry Leicester
Rafael López

Jason Lowe
Honey Luard
Scotia Luhrs
Soichi Maisumoto
Chantelle Marcel Clement
Tim Marlow
Steve Martin
Fiona McHardy
Suzanne McKeever
Bebe Merino
Massimo & Paul Monks
Lucy-Laila Mowat
Clare Murphy
Heather Norris
Atsushi Oiski
Paka
Javier Panera Cuevas
Raphael Pennelaup
Dave Pikens
Georgia Pitts
Caoimhe Power
David Richter
Roach
S. Roche
Caleb & Melissa Ronaldson
Mark Rothman
Charles Saumarez Smith
Seffi
Josie & Roisin Seiffert
M. Shepherd
Lara Singer
David Smyth
Jonathon Spears
Mini-May Stott
Filipa Pereira-Stubbs
Tomoko Suwa
Stuart Sweeny
Sam Sweeting

Ayako Takei
Toshie Takeuchi
Vicky Thornton
David Tweedy
Vipakee Vimolmal
Paul Vinell
Pachelle Wallace
Madeline Warren
Ben Weaver
Tim Wheeler
Colin Wiggins
Sam Williamson
Graham Wood
Kevin Wright
Michael Yee-Chong
Ana Zolotuhin

DA2 Domus Artium 2002
The Dolphin
John & The Eaton Mission
Hackney Archives
The Hackney Gazette
The George Tavern
New Lansdown Club
London College of
 Communications,
 University of the Arts
 London
Metropolis
The National Art Collection
 Fund
Ye Olde Axe
The Photographers' Gallery
John & Pub on the Park
The Saturday Times
 Magazine
White Cube
The White Horse

PICTURE CREDITS

Amsterdam
Rijksmuseum, Amsterdam on loan to the National Gallery,
London © Rijksmuseum, Amsterdam

Buffalo, New York
© Albright-Knox Art Gallery, Buffalo, New York

Dresden
© Gemäldegalerie Alte Meister, Staatliche
Kunstsammlungen Dresden. Photo Estel/Klut 2005

Dublin
The National Gallery of Ireland, Dublin © Courtesy of
The National Gallery of Ireland, Dublin

Florence
Galleria degli Uffizi, Florence © 1995. Photo Scala,
Florence – courtesy of the Ministero Beni e Att. Culturali

London
Tom Hunter © Tom Hunter. Courtesy of Jay Jopling/White
Cube, London; Tate, London © Tate 2005; The National
Gallery © The National Gallery, London 2005; The Samuel
Courtauld Trust © Courtauld Institute of Art Gallery, London

Paris
Musée du Louvre, Paris © RMN, Paris. 19, Photo Gérard
Blot; 24, Photo René-Gabriel Ojéda

Private collection
© Tom Hunter. Courtesy of Jay Jopling/White Cube, London

Valletta
Co-Cathedral of St John, Valletta, Malta © Photo Bridgeman
Art Library, London